PASTELS
Made Easy

ANNE HEYWOOD

WATSON-GUPTILL PUBLICATIONS / NEW YORK

Frontispiece

Susan's View of Damon's

Pastel on granular board, 14 x 17" (36 x 44 cm).

Private collection.

Title Spread

Snow Fence II

Pastel on pastel paper, 13½ x 21½" (35 x 55 cm).

Private collection

Senior Acquisitions Editor: Candace Raney

Edited by Robbie Capp

Designed by Barbara Balch

Graphic Production by Ellen Greene

Text set in Adobe Caslon

Copyright © 2003 Anne Heywood

First published in 2003 by Watson-Guptill Publications,

a division of VNU Business Media, Inc.

770 Broadway, New York, NY 10003

www/watsonguptill.com

Library of Congress Control Number 2003100819

ISBN: 0-8230-3908-0

Manufactured in the United States of America

First printing 2003

1 2 3 4 5 6 7 8 9 / 11 10 09 08 07 06 05 04 03

O Di' ti fà zumpà una volta soltanto.

To my husband, Bob, my "rock" and fellow dreamer;
my son, Carlo, for his lifetime of love;
and in memory of my parents, Eileen and Albert Boretti,
for believing, from the very beginning.

ACKNOWLEDGMENTS

Special thanks to my students for making me think; to my friends and family for their unwavering encouragement; and to the Watson-Guptill staff, especially Candace Raney for her faith in this book; Robbie Capp, for her fine editing and endless patience; Barbara Balch, designer, and Ellen Greene, graphic production, for making everything look so beautiful.

About the Author

Anne Heywood was born in Rhode Island. In her teens, she moved to Italy, where she acquired a love of great art. Returning to New England twelve years later, she earned a B. A. degree in art at Bridgewater State College in Massachusetts, and began her active career as a dedicated artist. Her paintings are in public, corporate, and private collections in the United States and abroad, and her work and articles about pastel art have been published in several magazines and books. Distinguished awards have been bestowed on her by the International Association of Pastel Societies, Pastel Society of America, and the Salmagundi Club. She is a signature, associate, or artist member of those and other groups, including the Pastel Painters Society of Cape Cod, of which she is a founder, the Connecticut Pastel Society, United Pastelists of America, Associated Pastelists on the Web, the National Association of Women Artists, and the American Artists Professional League. A popular

instructor at the Fuller Museum of Art and the South Shore Art Center, both in Massachusetts, Heywood also conducts pastel workshops, serves on panels, and lectures in various settings. She lives and paints in East Bridgewater, Massachusetts, and Nobleboro, Maine. Her Web address is www.anne-heywood.com; E-mail, aheywood@anne-heywood.com

Contents

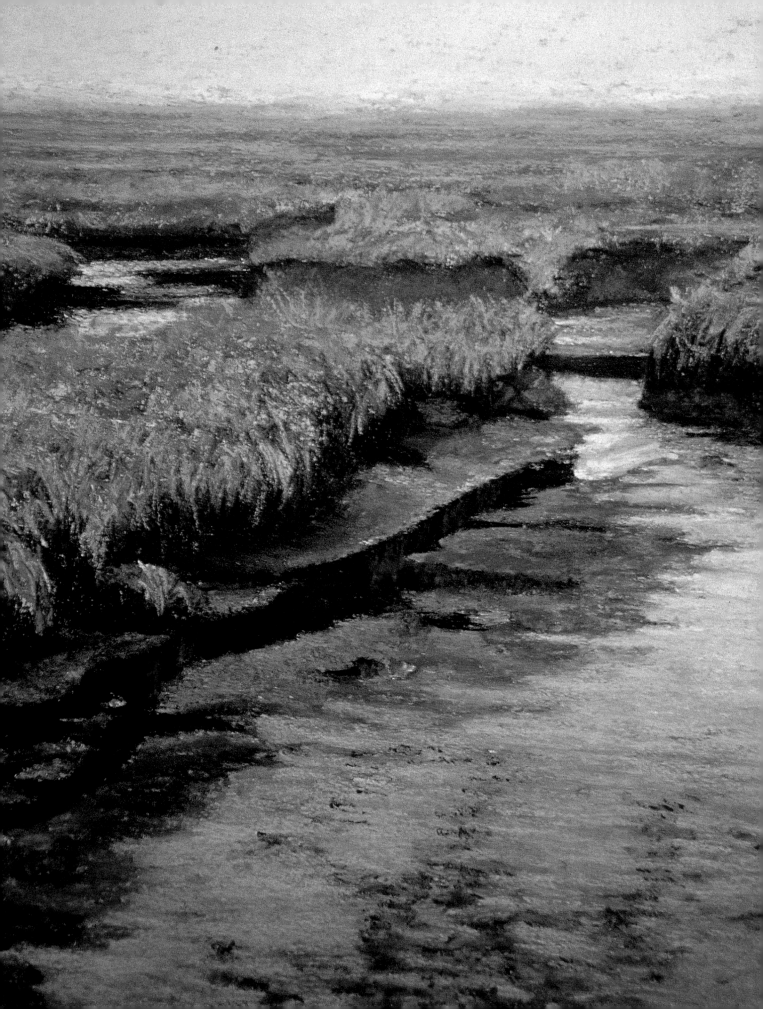

PREFACE

You've Made a Good Choice

Welcome to the colorful world of pastels. You've chosen a great medium, and—I hope you will agree—a very helpful book to tell you about it.

Today's growing popularity of pastels is no accident, since the medium fits our busy modern lifestyles perfectly. There are no brushes to buy or clean—colors go directly from the pastel stick to the painting surface—and all blending happens there, so you never need to spend time premixing colors. Nor does the pastelist need to worry about interruptions that cause paint to dry inconveniently; pastels are always dry, always ready to go. And, as far as correcting errors is concerned, pastel is a most "forgiving" medium, in that it lets you remove marks that you wish to change, eliminate, or replace.

Nearly thirty years ago, I bought my first set of pastels. After several attempts to paint with them, I relegated the set to a storage closet and went back to my watercolors. A decade later, I dusted the pastels off and began playing with them. This time, they rewarded me with some encouraging results, so I wondered what else I could do with the medium. Over the following years, I filled surface after surface with practice pastel paintings, and read countless magazine articles and books on pastels. But this is the book I wish I had had then. I've tailored the instruction in these pages to the format I devised for pastel classes I teach, which approach learning the medium in a logical, step-by-step, hands-on manner. The first chapter introduces you to the wide range of pastel materials and how to select, organize, and take care of them. The second chapter advises how to set up your work space and get started. In the next chapters, many pastel techniques are explored, with detailed exercises to help you gain control of pastels and how they behave. Demonstrations that incorporate those various techniques follow, as you create your first pastel paintings. Images of finished works are scattered throughout the book, along with information on color basics, composition, and how to store and transport your finished pastel paintings.

You've made a good decision to try pastels. Now, it's time for fun!

Opposite: **Low Tide**
Pastel on granular board, 17½ x 14" (45 x 36 cm).
Private collection.

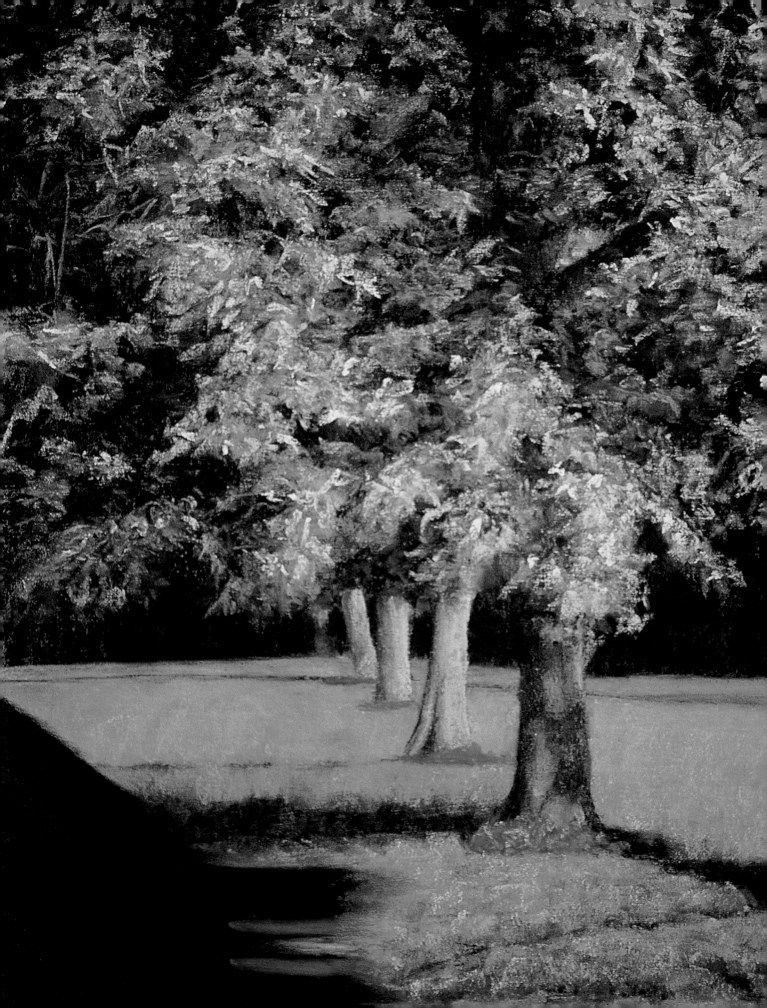

1 | MATERIALS

Pastel History

The first pastels evolved as an extension to drawing tools. Cennino Cennini's *The Craftsman's Handbook*, published in 1437, detailed how artists of that time created three-toned sketches using coal and white chalk on colored paper. Later in the fifteenth century, Leonardo da Vinci mixed iron oxide with pigment and chalk to make the first sanguine-colored drawing tool. By the end of the sixteenth century, a new technique of drawing with sticks of various colors had developed, and pastels were born.

Rosalba Carriera, a popular sixteenth-century Venetian portraitist, became the first artist to develop pastels from a sketching and drawing tool to a serious painting medium. Instead of using pastels only for preliminary painting sketches, Carriera covered her painting surface with layer upon layer of pastel, resulting in fine finished works. The popularity, beauty, and demand for her portraits, plus the immediate quality of the medium, convinced other artists to try pastels. By 1780, there were estimated to have been more than fifteen hundred pastel artists in the Paris area alone.

Opposite: **Crossroads: Medfield**
Pastel on granular board, 21 x 15" (54 x 38 cm).
Collection of artist.

Pastel Categories

All of those beautiful sticks of colors, beckoning from their warm wooden boxes! With today's resurgence of the medium, pastel supplies are stocked widely by art-supply stores and catalogues. Making sense of the differences among pastel groups and the vast choices of brands and colors available in each is not as daunting as it may first appear. But before you start buying, to be an educated shopper, it's wise to review the choices.

Most pastel brands are sold in sets of various sizes, and also by the stick. Generally speaking, the more colors you have to choose from when painting with pastels, the better.

Based on my personal experience with many brands, I have divided them into three general categories: hard, medium-soft, and very soft. Various manufacturers produce in each category, and pastel sticks differ in size, shape, and colors from firm to firm. Each brand has certain hardness or softness properties unique to its sticks, due to the ingredients used and the ratio of binder to pigment. The concept of hardness and softness is detailed below. Each manufacturer also makes its own range of colors. For example, the reds of one brand may have the same shade names as another brand, but the colors may differ considerably. That makes for numerous shades

and names that are impossible to remember, as is easy with other painting media, so many pastelists simply do not commit shade names to memory.

Very Soft Pastel

These are made from ground pigments, plus a binder to hold the pigments in stick form, plus a little preservative. Compared with other pastel forms, these are the softest in texture, can be easily blended, and allow generous application of color, putting down the thickest layers and marks with the most color "punch" and the least effort—that is, the least pressure on the stick. They contain the most pigment and are wonderful to use for the final layers of a painting, and for highlights and details. The companies that make fine, very soft pastels include Schmincke and Sennelier.

Medium-Soft Pastel

Medium-soft pastels are very versatile. They are good for making thicker and easier-to-blend layers and marks than hard pastels—but not as thick as very soft pastels. Many brands come under my medium-soft pastel category, and within that group, no two are exactly alike. For example, I consider both Holbein and Winsor & Newton pastels to be medium-soft, but in my opinion, Holbein are the harder of the two brands; similar comparisons can be made between other medium-soft pastel brands, which include Grumbacher, Rembrandt, Rowney, and Unison.

Hard Pastel

Hard pastels and pastel pencils are very good for making sharp, thin lines and light layers of color, and can be sharpened to a point with a single-edged razor blade or knife. NuPastel is the brand you'll find cited most often when I use hard pastel in the exer-

cises and demonstrations in chapters ahead; other brands that I recommend in this category are Conté and Derwent pastel pencils and Faber-Castell hard-pastel sticks.

Oil Pastel

Although oil pastel shares the common name *pastel* with traditional pastel, it is really considered to be a different medium altogether. I include mention of it to clarify that point, and to alert you to keep that fact in mind when you shop for your supplies of very soft, medium-soft, and hard pastels as covered in this book.

CLEANING TIP

Little pieces of pastel that are soiled (left) become bright and clean again (right) after shaking them in a small container filled with rice or cornmeal.

Opposite: Very soft pastels come in a vast selection of colors and are generally cylindrical in shape. Medium-soft and hard pastels, which may have flat edges and square tips, are also available in numerous colors.

Building Your Pastel Inventory

So, which kind of pastels are the right ones to use? I recommend using any and all of them. Try hard pastels, medium-soft, and very soft pastels exclusively or in combination when painting. Each type is naturally adept at specific tasks: hard pastel or pastel pencil for sharp lines; soft pastel for thick layers. Some artists use different brands for particular tasks in their paintings; others always work with only one pastel brand. Which pastels you use depends on how you work and the look you want in your finished painting. By experimenting with different brands, eventually you'll know which work best for you.

However, there is one important caution: Stay away from pastels that are labeled *student grade.* They contain less pigment than professional brands, and therefore do not render as much color when used in a painting. Their lightfastness—ability to withstand fading or changing color—is also inferior to better-quality pastels. Since the words *student grade* are not always printed on the pastel set, another way to identify them is that they usually cost much less than professional brands, and offer fewer color choices, even in their largest set; good brands always offer eighty or ninety colors in their largest sets. I am not suggesting that you buy a large set of pastels, but that you use that information in differentiating between student- and professional-quality pastels. A set of about twenty-five sticks of fine-quality soft pastel is sufficient to begin. As you gain experience, you can add individual sticks to it, or buy other or larger soft-pastel sets. In addition, a hard-pastel stick, NuPastel black, is good to have, since it is the easiest black pastel to control. And if you're lucky enough to find a set of pastels in the attic or at a garage sale, even old pastels are usable—as long as they're not moldy.

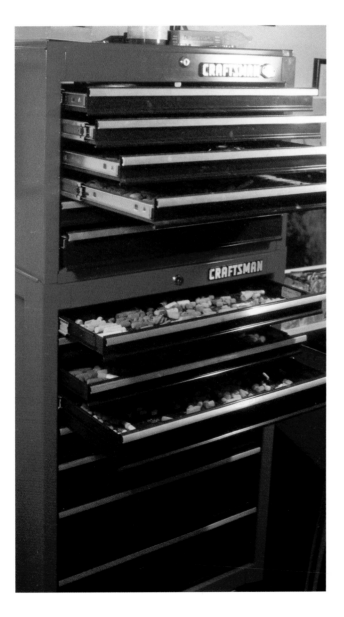

Left: My creative storage system has shallow drawers that group my huge supply of pastel sticks by color. Like most pastelists, I never throw fragments of pastels away; as they wear down, even the smallest pieces remain usable or can be recycled by crushing with a mortar and pestle, adding a few drops of rubbing alcohol, and shaping into sticks with gloved hands.

Keeping Pastels Clean

Pastels can get dirty from merely painting with them, since sticks will pick up a little of the colors over which they are applied. The easiest way to keep them clean is to get into the habit of wiping the sticks as you work, by keeping a clean rag in your non-painting hand. As a righthander, I hold the rag in my left hand, and every so often wipe off my painting stick. For the most part, it keeps my sticks in clean condition.

Pastels also become messy from bumping against one another while being moved or transported. When buying a set of pastels, notice that the individual sticks are packed in foam or other material to protect the sticks against breakage—and it also prevents them from touching each other. To keep them looking as bright and colorful as when you buy them, carry the sticks in their original packing when working on location or going to a class or workshop. There are also boxes made just for transporting pastels—some are even made to fit in an aircraft's overhead luggage bin—and there are numerous homemade solutions, such as a tissue-padded fishing-tackle box. If you have small pieces of pastel that are too difficult to wipe with a rag, here is a way to clean them. Take a clean plastic container with a lid (as from margarine), and fill it halfway with rice or cornmeal. Put small pieces of pastel in, cover, and shake the container for several minutes. Open, and if the pastels aren't clean, shake again until they are. Hard pastels take the longest to clean. Use the container over and over again, but replace the rice or cornmeal before it spoils.

Organizing Pastels

If you have a small set or two of pastels, your colors are already organized. But as you add to your pastel collection with other sets or single sticks, keeping track of what's where can be daunting—unless you organize your colors. Professional pastelists devise their own systems. Some need to work with very organized materials, while others just search for the pastel sticks they need when they need them. Most artists fall somewhere between the two extremes, and that is where I put myself.

I must confess that I am a label ripper. As soon as I get new pastels, if the sticks are covered with wrap-around labels (not all pastels have them), I usually remove the labels so I can see the whole stick, because it's hard to identify a color once the exposed tip of a pastel stick is used up—and peeling wrappers in the midst of painting is too distracting. However, a drawback to stripping off labels is not being able to identify the brands later, when you want to replace those sticks. As you become more experienced in handling pastels, you'll find a difference in the feel of the sticks from brand to brand while painting with them, and it will be more possible to identify your favorites. Also, if you collect color charts from various pastel manufacturers (retailers usually give them out), you can identify colors by comparing your sticks to those color charts. Or, before completely using up a pastel stick, make a mark with it on paper, and find that color in one of those various color charts. This is not a failproof system, but it works quite well for me.

When I'm painting, it is absolutely necessary for me to be able to find the color I'm looking for without losing my concentration, so I have organized my huge collection of pastels in the shallow drawers of a large, free-standing toolbox. Each drawer is lined with paper and sectioned into rows. Grouped by color—reds together, blues together, and so on—one drawer holds all my hard pastels; several drawers hold my medium-soft sticks; several more drawers hold very soft pastels. Each color group is then further divided into value groups: light reds form one group; medium reds, another; dark reds, another; and so on. You may not have many pastel sticks to organize yet, but as you go along acquiring new ones, keep them arranged so that you can see the colors clearly and find what you need easily, thereby enhancing your enjoyment of painting with pastels.

Paper and Other Surfaces

The surface on which you paint affects the quality and durability of your painting. Ideally, you should paint only on surfaces that are acid-free or pH neutral. Acid breaks down paper and board fibers, ultimately destroying those surfaces. For example, a paper that contains high levels of acid, such as newsprint, will yellow and crumble with age. So when choosing a surface to paint on, look for conservation-friendly papers, boards, or other supports. Those that are acid-free or pH neutral usually state that on their packaging. But be aware that even when shopping in a fine art-supply store, some art papers and boards sold there may not be acid-free or pH neutral, so verify their quality with a salesperson if packaging doesn't give you that information.

As for types of surface, pastels can be painted on nearly any kind of support, except for very smooth ones like bristol board and copy-machine paper. Sanded paper and certain other rough surfaces are made specifically for pastel work, but some artists also

Below, top left: Pastel papers come in many different colors. Choose according to the paricular qualities of the painting being planned.

Below, bottom left: Observe how different the same three colors look on these three different papers. The paper color you choose affects the look of your pastel colors, so as you paint, constantly compare the bare paper color to the painted areas.

Below, right: Painting with the same pastel on various colored surfaces illustrates the different looks that each lends to the same color. On which surface does the blue look brightest? Which darkest?

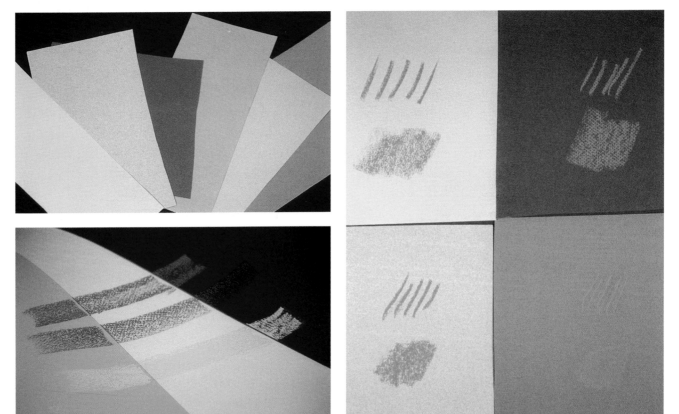

use mat board, watercolor or printmaking paper, or canvas panels. This versatility makes working with pastels endlessly exciting. For my own pastel work, I began with, and still sometimes use, Canson Mi-Teintes paper, which is easy to find, moderately priced, sturdy, acid-free, and has a smooth and a rough side, either of which may be used. Now I work most often on textured surfaces, such as Wallis or Colourfix paper or "homemade" granular board, which I make by coating four-ply museum board with a diluted solution of acrylic paint and a grit such as finely ground pumice or marble dust.

Texture, or "Tooth"

In order for pastel to stick to a painting surface, it must have some "tooth"—the term used to describe the depth of the crevices, or "hills and valleys," of that surface. Sometimes paper tooth is not very obvious, such as with smooth pastel papers whose texture may be more readily detected by touch. With sanded paper or rough pastel paper, the tooth is easily detected by sight as well as touch. In general, papers with deeper tooth can accept more layers of pastel; the finer the tooth, the easier it is to paint with great detail on that surface. Therefore, the tooth of a surface affects the look of the finished painting (just as a watercolor painted on smooth paper will differ from the same watercolor painted on rough paper). For a striking test of this concept, run a pastel stick across smooth pastel paper, then across sanded paper, and compare the two. The amount of pastel laid down on each in one swipe only will be considerably different. The degree that each mark can be smudged will also differ. Qualities such as these will affect the way you paint and the look of your finished painting.

Paper Color

Why do pastelists usually paint on colored paper, and how will you know which color to choose? Since tinted papers were used in the earliest days when the pastel medium was being developed, that practice has continued and been reinforced with wider ranges of paper colors offered through the years. Start with a sturdy pastel paper, such as Canson Mi-Teintes, which comes in medium grays, blues, yellow ochres, or tans, and is a good surface for beginners as well as experienced pastelists. This paper has a rough and a smooth side, and painting on either side is fine. Try other surfaces over time. Experience will teach you which ones are most suited to your paintings.

But there are other reasons, in addition to tradition, for working on colored surfaces. In the first stages of a painting, much unpainted surface is still visible. As you use various colors to develop your painting, continually observe those colors as compared with your still-unpainted surface color. Since white is the lightest and brightest value (*value* being the lightness on a scale of gray running from black to white), if the surrounding unpainted surface is white, then all colors look comparatively dull and dark. If the unpainted surrounding surface is black, then all colors look comparatively bright and light. But when the unpainted surface is a medium value, all colors placed on it look relatively as bright/dull and as dark/light as they truly are, since they are being compared with a medium value. Therefore, pastel artists often paint on medium-value paper, because it provides them with good color comparison as the painting progresses.

Another reason for working on a colored surface is to unify the painting by leaving the paper tone partially exposed as part of the finished painting. You may therefore choose your surface color based on the predominant color of your subject. Gray paper, for instance, might be good for a scene of a rocky coast; blue paper for a seascape. By leaving areas of the painting bare to expose the surface color, the paper color becomes part of the painting's palette.

Pastelists may also choose a surface color for its overall impact on the painting. For example, if your

subject is a red apple, a green surface will add color excitement, because a cool green is the complement of a warm red. Another choice for the same red apple might be a red paper, to reinforce the warmth of the subject, rather than provide a contrast to it. But with either choice, obviously, you must leave some "pinholes" of paper color showing through your subject to achieve the desired impact.

Whether you use a colored surface due to tradition, for the ease of choosing your painting's colors while painting, or to unify or give more color impact to your painting, finding the right colored surface is basically a matter of personal preference, which develops as your painting experience grows.

As your inventory of surfaces grows, experiment with each. Simply stroke the same stick on several different surfaces, and compare them. Below, to illustrate such varying results, look at the difference in marks produced by the same pastel stick on five different types of surfaces. In addition to using commercial materials, professional artists may prepare homemade pastel surfaces; one of mine is included below.

Top row, from left: Colourfix pastel paper. Handmade granular board. Canson Mi-Teintes smooth paper.

Bottom row, from left: Canson Mi-Teintes rough paper. Cold-pressed watercolor paper. Neutral surface colors are popular choices of pastel artists.

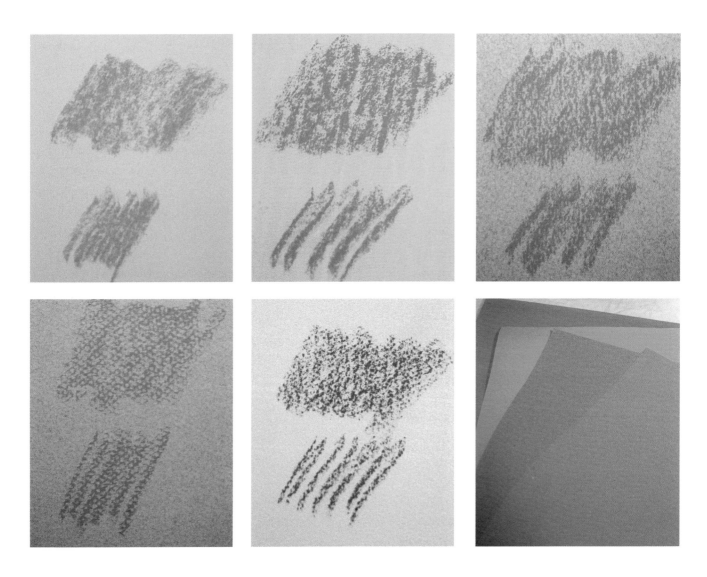

Other Tools

Although artists need less equipment working with pastels than with almost any other medium, there are other tools, in addition to pastel sticks and surfaces, that will enhance your painting experience—some of which are essential. They can all be found in art-supply shops and through catalogues. (Fixatives are not included in this chapter, because I do not recommend them; more about that in Chapter 6.)

I strongly suggest that you wear a tight-fitting plastic glove to protect your painting hand from being constantly stained with pastel particles.

Gloves

When handling pastels, I always wear a plastic glove on my painting hand (some pastelists wear gloves on both hands). I developed that habit one winter, when my fingertips were cracked and bleeding from the cold, and have continued the practice—which I recommend to all pastel artists. Wearing a glove while painting takes some getting used to, but it will protect your hand from being constantly stained with color, and prevent pastel particles from getting into skin cuts or scratches. It is very important that the glove fit as tightly as possible, since it will loosen up a little while working. Don't wear those yellow plastic gloves meant for washing dishes; they won't fit tightly enough. Gloves made for medical use (non-sterile is fine) work well. Some artists use barrier creams instead; I don't like them. But if you use cream, get one that is oil-free, since oil can taint pastel sticks.

Drawing Board

The purpose of a drawing board is to back your painting paper with a uniform hardness. However, instead of using a board, some pastelists rely on the stiffness of a paper pad to support their work as they use one sheet at a time within the pad. But I do not recommend painting that way, because the pad's hardness will diminish as its paper is used up. So if you buy paper in pads for finished paintings, simply tear the sheets out as you need them, and affix them to a drawing board. If you want a less-hard surface to paint on, pad the board with other sheets of paper—but don't use paper that is rough, creased, or smaller than your painting. Such irregularies will affect your finished work.

Drawing boards can be used with or without an easel (easels are discussed in our next chapter), and they come in various sizes: 18" x 24" is a standard choice. Some boards have a convenient cut-out handle and come with clips and a large rubber band with which to affix your paper. A homemade drawing board is another option, simply made by cutting a piece of luaun plywood (which has one smooth side) to size. However, I recommend padding such a board with several sheets of paper to separate the board's woodgrain texture from your paper surface. Caution: Don't use cardboard, Fome-Cor, or Plexiglas as a drawing board. Those surfaces are either too soft or easily bent or dented.

Charcoal

Vine charcoal is lightweight, used (instead of pressed charcoal) for a pastel painting's initial sketch. It is particularly adapted to this purpose, since it can be lightened easily, with no excess charcoal left to stain the initial layers of pastels that will go over it—a technique that will be described in a later chapter. A medium-soft charcoal pencil easily gives dark marks that can be smudged to obtain various shades of gray when doing preliminary sketches.

To clean a blending stump or tortillon, run it over fine sandpaper.

Eraser

I prefer a kneaded eraser, the type that can be fashioned into odd shapes to fit any space. It leaves little residue to be swept away, unlike most other erasers. I use a kneaded eraser mainly for correcting my vine charcoal sketch—not for erasing pastel.

Bristle Brush

For removing pastel, a new or used medium-size bristle or synthetic brush will do the job, without damaging your painting surface. Softer brushes, such as sable, do not work as well as brushes with stiffer bristles.

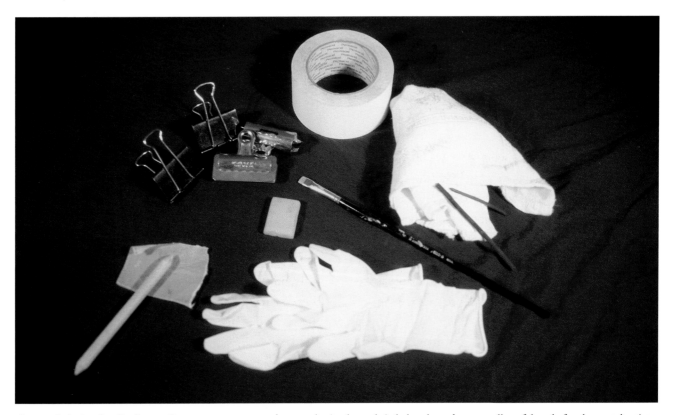

Counterclockwise: A roll of tape, clips, eraser, stump, sandpaper, plastic gloves, bristle brush, and a rag—all useful tools for the pastel artist.

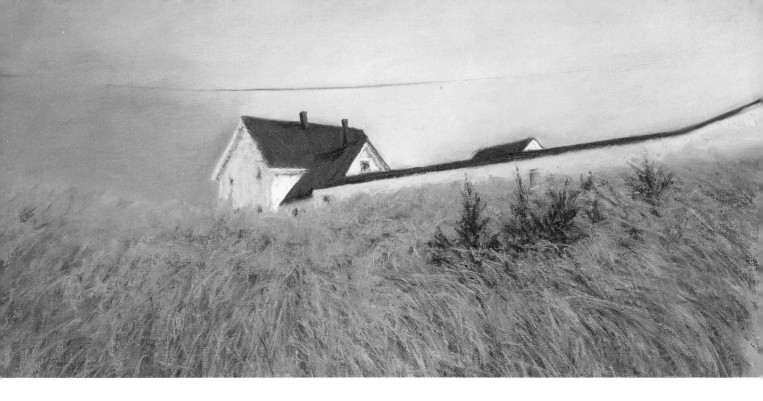

Blenders

There are two tools for blending pastels: A tortillon is a tightly rolled paper cylinder with points at each end; a stump (also called *stomp*) is flat at one end, pointed at the other. Both are inexpensive blending tools that last a long time. They can be cleaned and their points restored by running their tips over sandpaper.

Sketch Paper

I am a firm believer in the merits of black-and-white sketching before painting. Use a small sketchbook, pad of newsprint, or pieces of scrap paper to explore your painting's subject matter, before working on your chosen pastel paper or other surface. Using charcoal, work out the shapes, sizes, and position of your subject's forms, as well as their range of dark-to-light values. Preliminary sketching will help you eliminate potential problems before committing valuable hours, days, and weeks to a painting.

Miscellaneous Aids

Some artists secure their paper to the drawing board with elastic bands; others use the drawing board's

On the Hill
Pastel on granular board, 23 x 33" (59 x 84 cm).
Private collection.
Blues transitioning to yellows make for a fitting backdrop to this scene's roofs, painted with very soft red pastel. With dark-blue hard pastel, I added the suggestion of a power line after I finished the sky. The "white" building is actually a combination of medium-soft pastels in very light blue and orange, and a very soft stick of very light yellow. In the foreground, I used black, dark green, reds, oranges, and golds, taking advantage of the different properties that each type of pastel offers: thin grasses, hard pastel; medium-thick grasses, medium-soft pastel; thick grasses, very soft pastel.

clips or large clips from an office-supply store, but care should be taken not to dent the paper's edges with too sharp a clip. I use large clips or artist's tape, since it can be peeled off without damaging the top layer of paper (as masking or other tapes might).

A clean rag is useful for wiping off pastel sticks to keep them clean of other colors. Since pastel painting entails a lot of layering of colors, one over another, an unexpected color can be carried on a stick. Avoid this problem by cleaning sticks as you work.

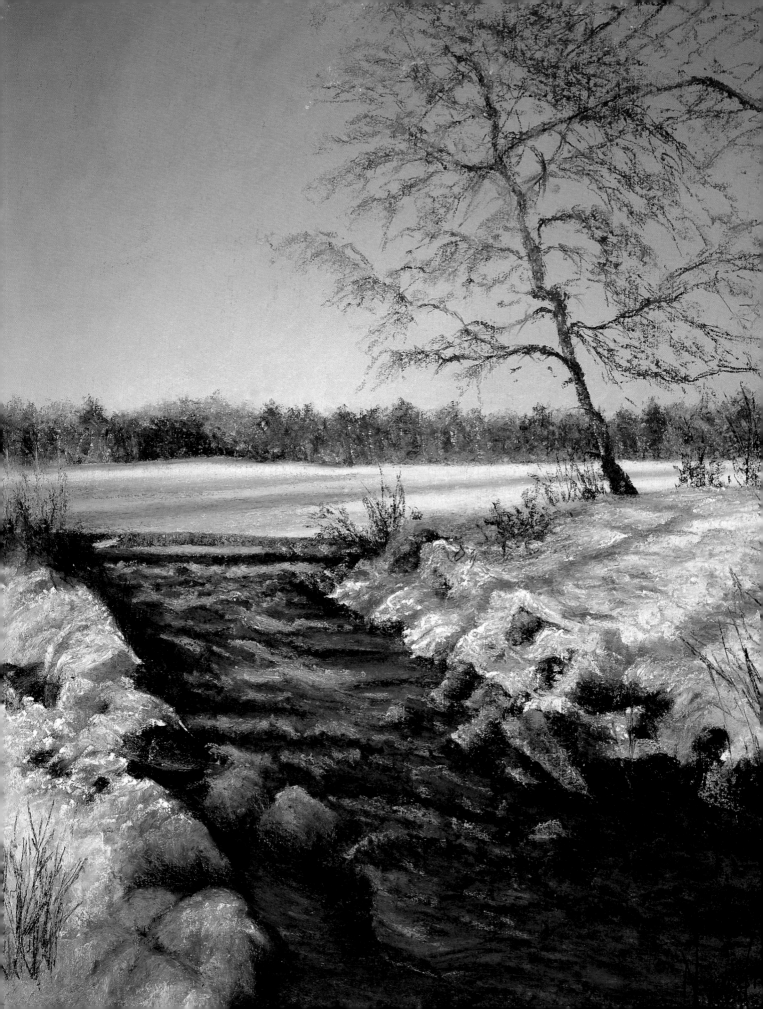

2 | GETTING STARTED

A Place to Paint

Now that your materials are assembled, the important next step is to find a place to paint. Unlike the romantic notion of artists creating only when "inspired," the reality is that it takes concentration, dedication, and plain hard work to paint. So, you will need to establish a spot indoors where you can paint undisturbed.

Some professional artists have studios designed to fit their every need; others (myself included) get by with less. But nearly everyone's first painting area was the corner of a basement/attic/garage, a large closet, a spare room, or a very low-rent space away from home. Creative solutions to finding painting spaces abound. Ideally, you'll find a quiet space that will allow you to concentrate on painting—an area with good lighting (natural, artificial, or both), where you can leave your materials safely, without having to put them away and clean up each time—and a space that will also be physically comfortable. You can outfit your painting space even on a modest budget—tips for equipment follow—and a radio or CD player will add your favorite music. However humble, make your studio an area that you will enjoy being in every time you paint.

Lighting

I prefer, as do most artists, to paint by natural light. But if you don't have daylight streaming in your windows, small clip-on lamps sold in hardware stores can provide effective lighting. For the professional or other artist who paints for long hours on a daily basis, a more planned lighting system may be required. I use color-balanced lighting. Years ago, I noticed that standard household bulbs cast a yellow-tinted light. That discovery signaled the beginning of my search for a better artificial light source. I bought one bulb of nearly everything available for color-balanced lighting, and tried working with each one. That resulted in the combination of lights that I use now, which, by the way, was not a costly solution.

Opposite: **Borderland**
Pastel on granular board, 24 x 18½" (61 x 47 cm).
Collection of artist.

Easel Choices

Among the many types of easels, a free-standing floor easel is a popular choice of pastelists. But not everyone likes using an easel, although I find that many who feel that way are simply hesitant to use something they've never tried before. If you're in that group, here are some good reasons to give an easel a try.

If you work on an easel with pastels, any pastel particles, or dust, that do not adhere to the painting surface will fall down. If your painting is placed perpendicular to the floor or, better yet, tilted a bit forward, pastel particles will completely miss your painting and fall directly into the easel's tray or on the floor. But if, instead of working on an easel, you put your drawing board tilted between a table and your lap, some of that dust will fall into your lap. Worse yet, if your drawing board lies flat on a table, pastel particles will be pushed around and incorporated into the painting as you work. If you don't want your painting to look like the gray pastel dust that is being pushed around, then it's time to consider working on an easel.

Another advantage to an easel is that it offers a fine vantage point for viewing your work in progress. Every pastel artist paints at no more than an arm's length away from the surface. At that distance, you see only the small picture as you examine your work section by section, without getting a good look at how the painting is progressing as a whole. Standing at an easel, it's easy to step

Below, left: An easel should be upright for pastel work, rather than tilted back, so that the pastel particles that do not adhere during the painting process can fall right down into the easel tray or to the floor, rather than drifting down and discoloring a lower part of the painting, below the area you're working on.

Below, right: When you place your drawing board on an adjustable, free-standing floor easel, be sure to position the easel straight upright for pastel painting.

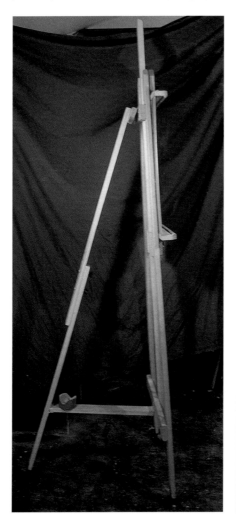

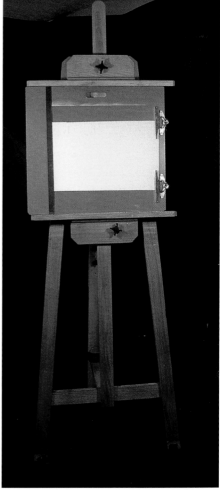

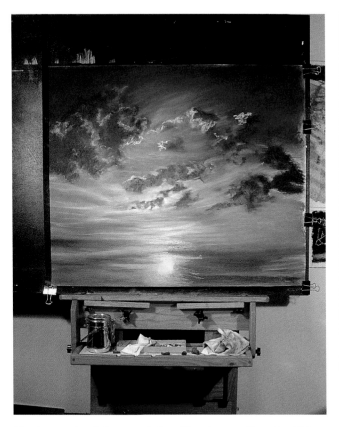

Easels come in all shapes and sizes. Here is my wall easel, which I like to use for my larger pastel paintings.

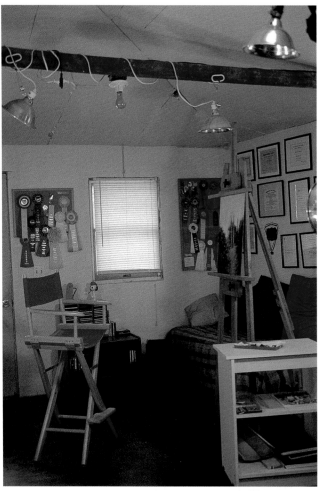

Although I am always thinking of ways to improve my studio, it has evolved over the years into a quiet, comfortable space where I can create my art in peace. I'm lucky to have a window nearby, but augment its natural light with clip-on lamps and other artificial lighting as needed.

back—or push your chair back, if you paint sitting down—and view the entire work. And it is also much easier to keep your lines of perspective accurate when being able to view your work upright on an easel.

When shopping for a floor easel, my advice is to go to a store that has some on display, and test each one that falls within your budget. Change the easel's position, move the bottom tray up and down, slide the top clamp up and down, and push on the center mast to see how steady the easel is. Make sure it can accommodate the size drawing board you will be working on, which depends on the size paintings you intend to do. And if possible, get an easel that has wheels (that lock); it 's surprising how often an easel may have to be moved. Also consider the height of the center mast, to be sure your ceiling will accommodate it. Most important of all for pastelists, choose an easel that is sturdy and easy to adjust to an upright position.

In addition to floor easels, there are table and wall easels, as well as non-easel alternatives that will still allow you to work with your painting surface in an upright position. The first and best one that comes to mind is simply a wall. If you have access to a smooth, blank wall that you can tape, tack, or nail your painting surface to, it will work well as a substitute easel. You might pad the wall with extra sheets of paper to protect against surface irregularities. Or you can use an adjustable wall-shelf system to hold your drawing board and painting surface. These are both economical solutions to working upright.

Preparing Your Drawing Board

As suggested in the "Materials" chapter, you may or may not choose to pad your drawing board with other sheets of paper. Affix your pastel paper to the board with tape, large clips, or elastic bands, making sure the paper is flat, buckle-free, and tightly secured. If the paper extends beyond the board, cut it to be slightly smaller than the board. Those loose edges of paper cause problems, so it 's best to cut off any excess before painting.

Before placing your drawing board on your easel, position your easel with its mast (central vertical bar) as perpendicular to the floor as possible. Each easel adjusts in its own way, so to make yours straight upright, you may have to counterbalance it with a weight on its back leg. Once your easel is adjusted, secure your board between the bottom tray and top clamp at a comfortable working height, based on whether you will be standing or sitting while painting.

Worktable

A kitchen utility cart on wheels makes a wonderful worktable at less than half the price of an artist's taboret, but serves the same purpose: having a small cabinet near the easel, so the artist can easily see and reach for all the materials that will be needed for the painting session at hand.

Whether you use a cart, a table, or other furniture, position it according to your dominant hand—to the right or left of your easel—and have it close enough to reach down, locate, and grab the pastel sticks you need as you need them.

Large clips are one device for securing the painting surface to a drawing board. (Artist's tape or elastic bands also serve the purpose.) The easel's top clamp keeps the drawing board locked in place.

Here, I've repositioned my drawing board, placing it on its side in preparation for a landscape painting that will have a horizontal format. Orienting your paper and drawing board is a basic first step when you start a new painting.

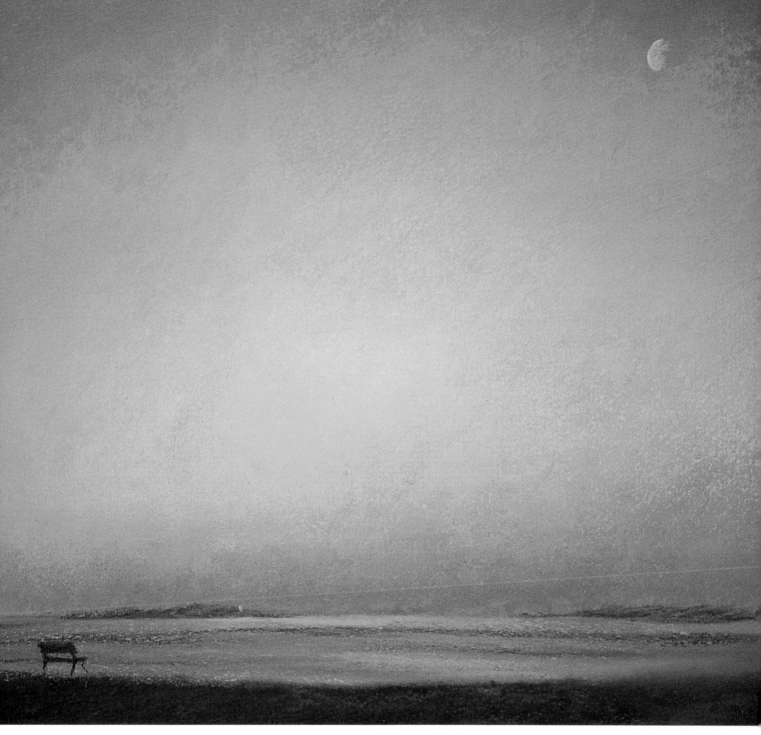

Moonrise (detail)
Pastel on granular board, 20½ x 27½" (52 x 70 cm).
Collection of artist.

*Textured surfaces, such as the yellow-ochre granular board used here,
have a deep tooth, which can accommodate many layers of pastel. Colors
in this painting were built up, starting with hard pastels, over which
medium-soft were applied. Very soft pastels were used in the last layer to
achieve these rich colors.*

Choosing Your Subject Wisely

With the infinite range of subjects to paint, choosing should not pose a dilemma. But in reality, the decision may be hard when it comes to choosing subject matter wisely.

"Paint what you want to paint, within reason" is the advice I give my students. If you are going to spend hours of hard work on a painting, then the subject should be one that you enjoy and won't tire of or give up on. "Within reason," however, means that the complexity of a subject should be weighed before making your choice. So, if you are a novice with pastels, it is wiser to begin painting subjects such as single pieces of fruit, and paint them well, rather than attempting family portraits, painted badly. Remember, even the great Old Masters devoted much time to sketches and studies before creating their finest finished work.

Still-life setups are the best choices for your initial pastels, since all the visual information is simply and easily in your control. Start with one or two long-lasting fruits or vegetables that have simple shapes. The exercises and demonstrations that lie ahead will show you how. Once you've gained experience, choose more complex objects, such as flowers and bottles that appeal to you, or perhaps depict some of your personal mementos. After you learn how to control pastels and achieve the effects you want with still lifes, try your hand at a landscape, which will be demonstrated in a later chapter.

Painting from Life

If you paint from life, no matter what the subject, it will be easier if you can see both your subject and painting surface by merely moving your eyes, without

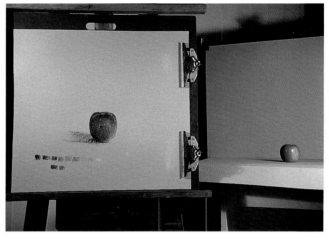

Your painting subject and your painting surface should be easily visible within your line of sight. An apple is a good choice of subject matter for the beginning pastelist.

having to move your head or body. Painting from life requires careful, ongoing observation of both the subject and the artwork, so if your view of either is blocked, causing you to move your head or body, you run the risk of becoming uncomfortable in a short time. In addition, there is what I call the "click and drag" phenomena. When your eyes "click on" an object, it is easier to "drag" that image in your memory to a nearby spot, rather than a distant one. So, always keep your subject and surface visible within your line of sight.

You do not have to be very close to your subject in order to paint it. Since a good painting begins with blocking in the largest masses, some artists prefer to start at a distance from the subject and see only its general characteristics and largest shapes. As the painting progresses, with smaller masses and details added, the artist moves closer to the subject for more careful observation.

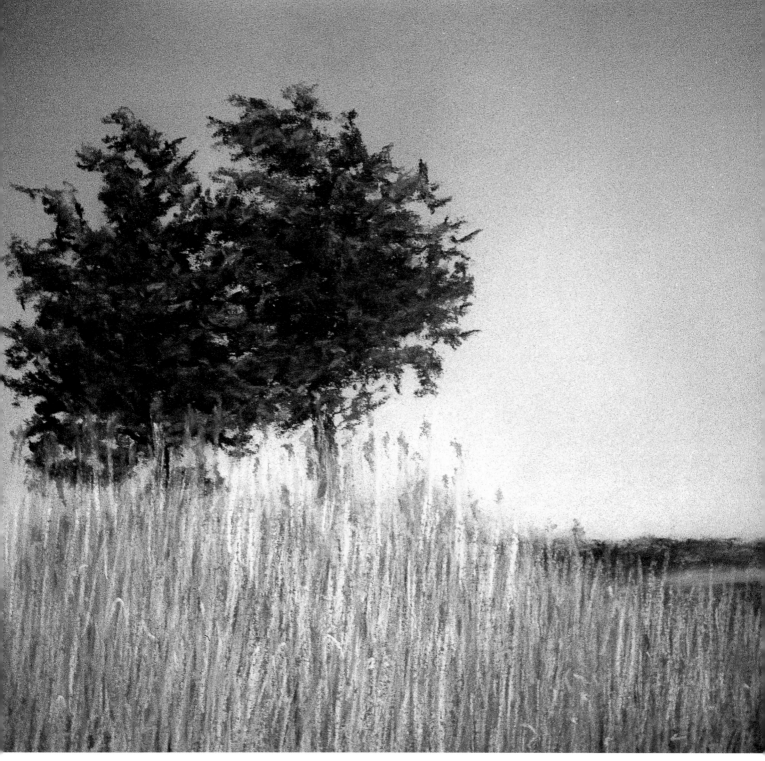

A Couple (detail)
Pastel on pastel paper, 11 1/2 x 17" (29 x 44 cm).
Private collection.
Whether a landscape is painted on location or from photographic
reference, such as in this case, the pastel medium offers artists a huge
range of colors with which to interpret nature's beauty.

Painting from Photographic References

Many artists prefer to photograph their subjects and work from them in the comfort of their studios. Today's cameras produce high-quality prints and slides and are handy to use, particularly with animated subjects. With the development of digital cameras, artists may also use images on computer monitors and color copies from computer printers as painting reference.

If you choose to paint from photos, keep in mind that even the best pictures do not always record all colors that are present in reality. For example, dark shadows in a landscape often look like large black masses in a photo, when, in nature, those shadows are comprised of various hues. So, if you use a camera, you should also oberve and commit to memory—or better yet, make notes about—the colors and details you see that you observe in person. And since the best-quality photographs make the best reference materials, use prints large enough to see easily—4" x 6" or larger.

When photographing outdoors, avoid taking pictures at high noon, when sunlight is the strongest and washes out colors. The best time is when the sun is low in the sky, such as early morning or late afternoon, which will give you the best colors. If you photograph indoors, try to use natural light. Artificial light, depending upon the type of film you use, may produce a noticeable yellow tint on the photo.

Finally, prepare many photographs, even if you have only one subject. Shoot from different vantage points and heights. When using photographs as reference, many visual questions will come up when you begin painting. You will be pleased to have many different views to give you the answers you need.

Below: Photographic and digital references are common tools used by today's artists.

Opposite: **Stump**
Pastel on granular board, 17¼ x 14½" (44 x 37 cm).
Collection of artist.

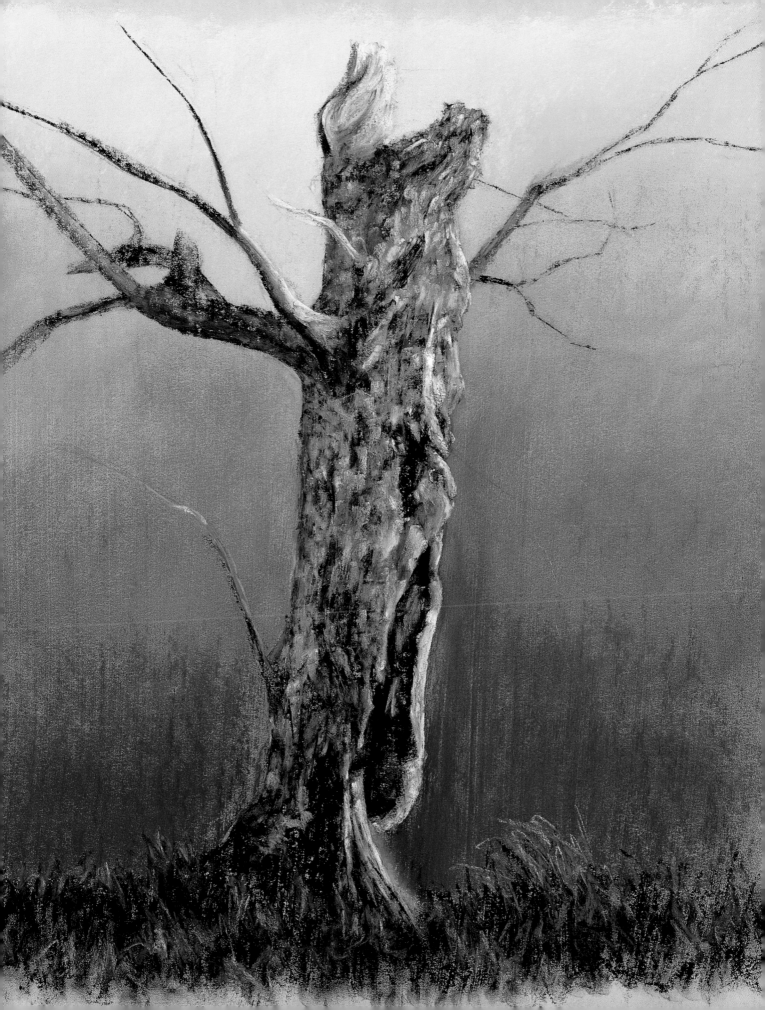

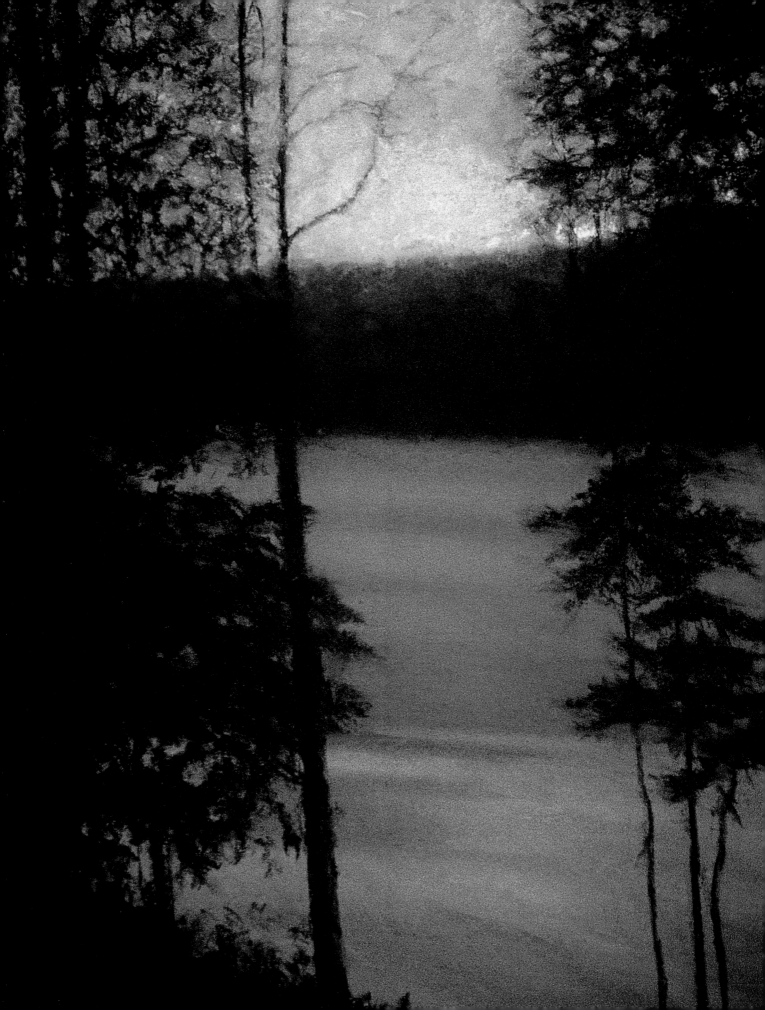

3 | BASIC TECHNIQUES

Making Strokes/Marks

It's always easiest to begin a new friendship with a proper introduction. The hands-on exercises in this chapter will introduce you to basic pastel techniques, enabling you to gain control of the medium, step by step. We start with the most basic strokes (also called marks) made with pastels. Like your signature, the marks you make are unique to you. The materials you will need for all the exercises are listed below.

Materials
- *plastic gloves*
- *pastels: 1 each (medium soft) medium blue, yellow, white, orange, dark blue; (hard, NuPastel) black*
- *pastel paper*
- *vine charcoal*
- *kneaded eraser*
- *rag*

SAFETY TIP

I suppose it is a natural tendency for pastel painters to simply take a deep breath and blow away those stray pastel particles. Unfortunately, blowing them only puts them back into the air, where they are more likely to be taken in with your next breath. There are much safer alternatives. Either dust your easel tray and studio surfaces with a damp cloth; wet-mop your painting area; or take your drawing board off your easel and bang the back of it gently to shake off any loose pastel particles, then vacuum or wet-mop them up from the floor.

Opposite: **Pastel Sunset**
Pastel on granular board, 27 x 16½" (69 x 42 cm).
Private collection.

Exercise: Pressure

With your medium-blue pastel, make three separate groups of marks on your paper, using the broad tip of the stick. Make the strokes in the way that you find most comfortable. If you are right-handed, your strokes may slant a bit to the right; if left-handed, to the left. Vary the pressure on the stick with each group: Apply light pressure for the first group; medium pressure for the second group; heavy pressure for the third group—and hold on to your drawing board for that one!

So you thought you bought one color when you bought one stick? Now you've discovered that the amount of pressure you apply to a pastel stick determines its color intensity. Look at the different blues

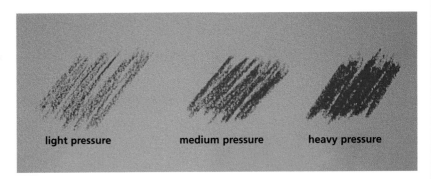

light pressure **medium pressure** **heavy pressure**

that different pressures produced. Think of the many variations of pressure that you're capable of applying, and that will give you an idea of how many different shades you can get from one pastel stick. For extra practice, repeat the above exercise with several of your favorite colors to see how many variations of each you can produce, simply by varying pressure exerted on each stick.

Exercise: Closed and Open Strokes

Draw a rectangle with your medium-blue pastel stick. Fill it with strokes placed close together, using medium pressure. This technique is called *closed stroke*. Draw another rectangle with the same pastel stick. Using medium pressure, paint randomly within the rectangle, leaving some paper showing through while trying to get an even distribution of strokes. This technique is called *open stroke.*

Back away from your easel and examine your work. The first rectangle looks uniformly blue, with little, if any, paper color showing through. The second rectangle also looks blue, but since some of the paper color is visible, the blue appears to have a different, lighter tonality than the more solidly applied closed strokes. So if you use open strokes, obviously, it's more important to choose your paper color carefully. For

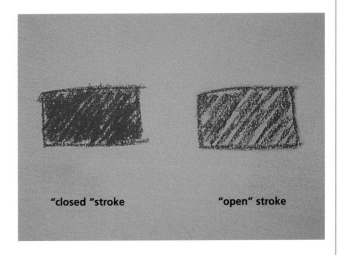

"closed "stroke **"open" stroke**

extra practice, see how many different blue rectangles you can paint, using variations of closed and open strokes, and varying the pressure you exert on your pastel stick.

Exercise: Optical Mixing

Draw a rectangle with your medium-blue pastel stick and fill it with open strokes. Then paint over the blue with your yellow pastel stick, using open strokes, the yellow going over or next to the blue strokes. As with the blue strokes, obtain an even distribution of yellow, leaving spaces among the strokes. When finished, the rectangle should be about half filled with blue strokes and half with yellow.

When you back up and look at your work, notice that your blue-and-yellow rectangle takes on a some-what greenish look—the result of *optical mixing,* which is what happens when we see colors from a distance. The Impressionists and Pointillists were famous for mixing colors optically: placing small dots or strokes of separate colors on their painting surface to

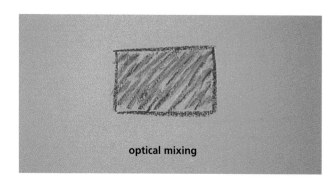

optical mixing

give the illusion, seen from a distance, of merged colors. For extra practice, use different blues and yellows to see other examples of optical mixng.

Since pastel sticks pick up the colors they paint over, wipe your sticks as you work.

Exercise: Closed and Open Optical Mixing

Draw four rectangles with your medium-blue pastel. Fill the first two rectangles with *closed strokes;* fill the last two with *open strokes.* Paint over the first and third blue rectangles with *yellow closed strokes;* paint over the second and fourth with *yellow open strokes.*

When you step back and examine your work, note that all four rectangles contain the same colors, but no two look exactly alike. Obviously, boxes one and two (closed blue) have more blue; boxes three and four (open blue), less blue; boxes one and three (closed yellow) have more yellow;

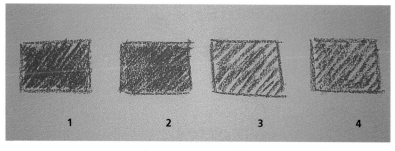

1 2 3 4

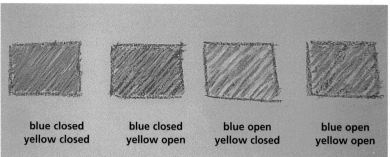

| blue closed yellow closed | blue closed yellow open | blue open yellow closed | blue open yellow open |

boxes two and four (closed yellow), more yellow. For extra practice, paint other rectangles, with the same blue and yellow, using the closed- and open-stroke techniques in different combinations.

Exercise: Color Order

Draw four yellow rectangles. Using medium pressure, fill in the first two boxes with closed yellow strokes, the next two with open yellow strokes. Paint closed blue strokes over the first and third, open blue strokes over the second and fourth.

Back away and observe how different this group of rectangles is from those in the previous exercise, although the same colors and amounts of each were used. Yet, no two in this exercise look exactly alike or like those in the previous exercise. Compare all eight rectangles and find the one that looks most yellow and the one that looks most blue. The conclusion to be drawn: The order in which you layer pastel colors affects the final result.

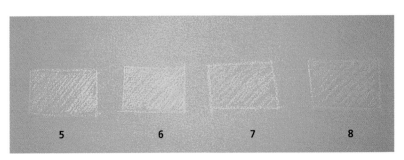

5 6 7 8

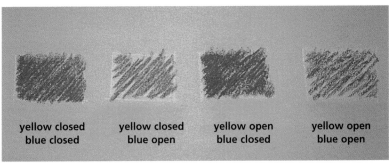

yellow closed
blue closed

yellow closed
blue open

yellow open
blue closed

yellow open
blue open

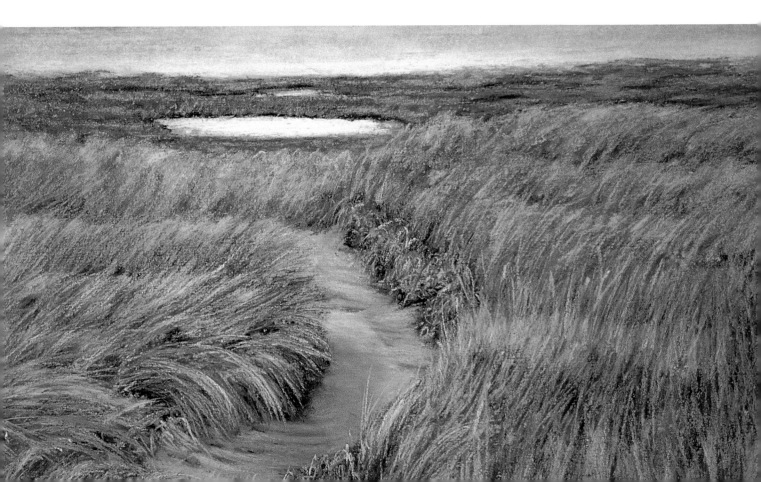

Exercise: Black-White Scale

Draw two long rectangles with vine charcoal. Flick the end of a clean rag over them until only a "ghost," or pale outline, remains. In the first rectangle, paint a subtle transition of color from pure black, at far left, to pure white, at far right. Begin with closed strokes of black on the left, and as you move right, open the strokes gradually, lightening pressure as go. Do not put any black at far right. Now apply white pastel in the same way, but in reverse direction: closed white strokes ar far right, then gradually more open strokes as you move left, toward the black. Once you have painted the white, resist the temptation of going back to adjust the black.

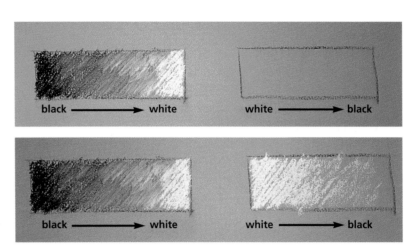

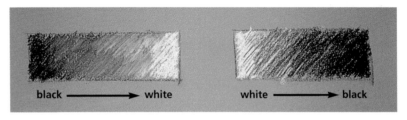

There should be a gray color in the center of your rectangle, where black and white have about an equal concentration. The transition of color should be gradual, from pure black to pure white, without obvious color jumps or stripes.

In the second long rectangle, as with the first, you are trying to get a subtle transition from black to white, but this time, in the reverse order. Instead of starting with black, paint the white first, using closed strokes moving to open strokes with lighter pressure. As in the first rectangle, resist going back over your strokes to adjust tones. When you step back and look at both rectangles, they will look different because of the order in which you applied your pastel. You may have noticed that it was more difficult to obtain a gradual transition of color in the second rectangle, and that the black is somewhat dominant. That's because it is easier to control color transitions when you paint the darker colors first, a method that is often referred to as painting from dark to light. But always keep in mind that black pastel is a very powerful color. Use it sparingly, in light layers. For extra practice, choose two of your favorite colors and make another color-transition scale. Then use three colors, filling a long rectangle with color transitions from color one, to color two, to color three.

Opposite: **Pool**
Pastel on granular board, 16 x 20" (41 x 51 cm).
Collection of artist.
Strong pastel strokes like these establish the growth direction of the grasses.

Exercise: Value Contrast

This exercise shows how to make flat shapes appear to be three-dimensional by establishing good value contrast between dark and light colors and tonality within colors. Begin by drawing three circles with vine charcoal. Working from dark to light, paint the first circle going from orange to yellow as you move toward the center, where you place white. Strive to obtain good color transitions by varying stick pressure and using open and closed strokes, as appropriate.

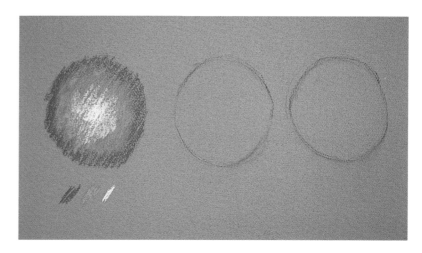

In the second circle, add dark blue to your palette. Since it is darker than orange and you are going from dark to light, paint dark blue at the outer rim with light pressure. Apply orange over it, going farther into the circle, then use yellow and white.

For the third circle, substitute black for dark blue, applied with very light pressure near the circle's rim. Paint orange over black, moving farther into the

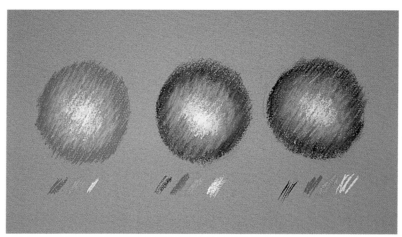

circle. Finish with yellow and white, as in the first circle. Again, strive to obtain good color transitions.

When you examine the three circles, the first should look least like a sphere, since it has the least contrast, the darkest color being orange, which is not very dark as compared with the other colors. The second circle looks less flat than the first because the dark blue provides greater contrast with the other colors. The third circle, with black instead of blue, looks most like a sphere, since it has the most contrast. But

remember, if you do not paint the black lightly enough, you will have an extremely dark circle. Black and other darks are powerful, so a little goes a long way.

For extra practice, place a smooth, solid-color ball on a table with a strong light on its left side. Keep other lights off in the room, while still being able to see what you're doing. Paint a picture of the ball, applying colors from dark to light. Use black or dark blue under other colors to suggest darkest areas, and make subtle color transitions.

Exercise: Direction of Strokes

The direction of your strokes is important, as this exercise demonstrates. Draw four circles with vine charcoal, and "ghost" them with a clean rag. Using the colors from the previous exercise, paint the first circle with strokes that follow the rim of the circle. Paint circle two using strokes that all radiate toward the center of the circle. Paint the third circle with strokes that all go in the same direction. For circle four, pretend you are running your hand over a ball. Notice the motions you are using, and use strokes that follow those motions.

When you stand back and examine your completed circles, the first should resemble a bull's-eye. Since the strokes follow the edge of the flat form, they reinforce the flat shape, making subtle color transitions difficult, and often leading to stripes—which is how *not* to paint with pastels. Circle two also looks like a bull's-eye—another example of how *not* to paint with pastels. Circles three and four show *good* application of pastel strokes. Conclusion: Either paint strokes in the same specific, controlled direction (as in circle three), or paint strokes following the three-dimensional form (as in circle four).

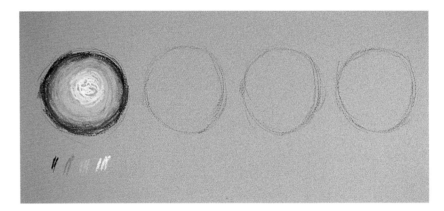

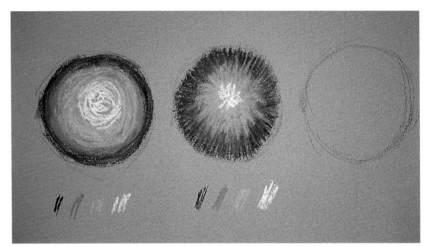

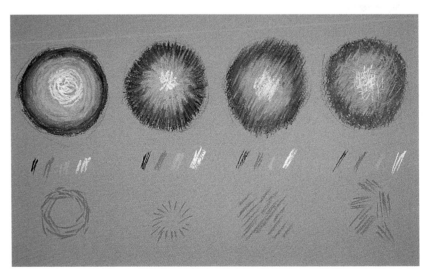

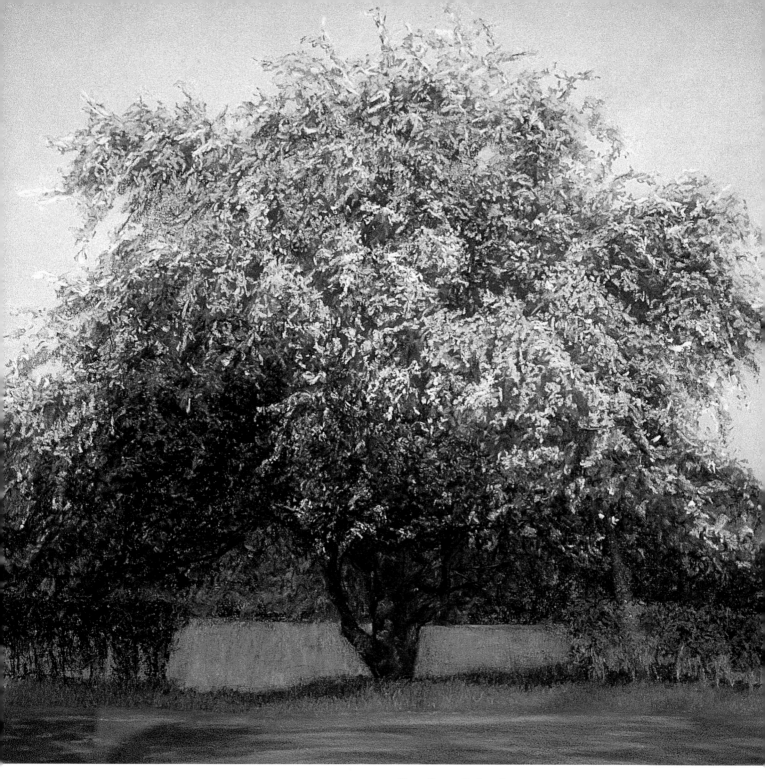

Cross Street Crabapple
Pastel on granular board, 23 x 29½" (54 x 77 cm).
Collection of artist.
The overall shape of this beautiful tree's spring crown reflected the tree's underlying structure of limbs and branches. By sketching out the large shapes within the crown shape, and by carefully controlling the placement of values when painting the blossoms, this scene grew into a dramatic subject.

DEMONSTRATION:
Realistic Orange

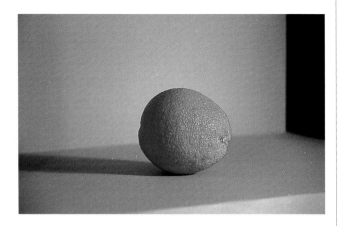

For your first pastel painting, try depicting an orange realistically. Before painting with pastels on pastel paper, work out values—all the darks and lights—with charcoal on sketch paper, as shown in the early demonstration steps.

Step 1: Setup. Place an orange on a light-colored paper (or mat board) on a table where it will be undisturbed for at least a couple of hours. Prop a second sheet behind the orange; the neutral paper color makes the subject stand out. Direct a single light on the orange from above and to the side, which produces a long, cast shadow. Direct another light on your working area.

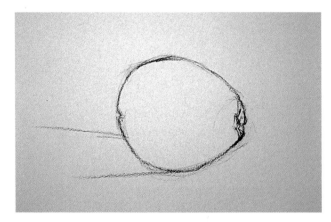

Step 2: Outline Sketch. Make a simple charcoal outline of the orange on white sketch paper. If you make a mistake, just erase it; no one has to see this sketch except you. Lightly indicate the direction of the cast shadow on the left.

Step 3: Values. Draw five small value boxes on your sketch paper. Using a charcoal pencil, fill in the last box with the darkest shade possible; the third box with a medium shade, halfway between the dark box and the white of the paper, which is the first box left empty; darken the second box in a shade between the first and third box; darken the fourth box in a shade between the third and last box.

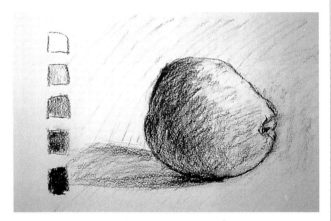

Find the darkest areas of the orange and its cast shadow and shade them as dark as the last box. Find the next-darkest areas and shade those to match the fourth box. Find the medium values and shade those according to the third box. Finally, find the almost-lightest areas and shade those to match the second box. Leave the rest of the sketch untouched, to represent the brightest areas, or erase for highlights.

Simplifying all the subtle shading down to five possibilities is the hardest part. Just erase and adjust as you go along. This black-and-white sketch is meant to help you envision values in the colorful painting you are about to create. Although doing a sketch for such a simple subject may seem overcautious, preliminary sketching is a good habit to cultivate, as it allows you to work out all major value elements before you begin to paint.

Steps 4, 5, 6: First Pastel Layers.
On off-white pastel paper, draw the
orange with vine charcoal, then flick a
clean rag over it, leaving just a light
outline visible. Study your subject to
identify the colors you see. Pick out
those colors from your hard pastels,
and lay them on a paper towel
arranged from dark to light. An
orange skin definitely has more colors
to it than the obvious one, so spend
time looking and choosing. The more
you look, the more you'll discover. We
build up to a total of eleven colors in
the palette I've chosen: black, dark
blue, red-orange, medium orange,
yellow-orange, medium dark blue,
red-orange, orange, yellow; light
yellow-green, very light blue.

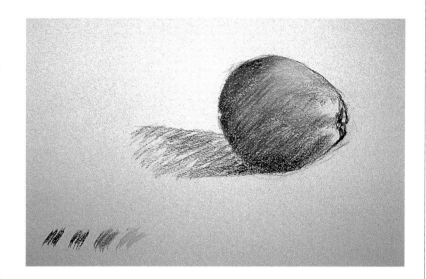

Begin applying color with hard
pastels by looking for the darkest
areas of the orange and painting them
with black, using light pressure. Find
those darks by referring both to the
orange and your value sketch of it.
Use dark blue for the next-darkest
parts of the orange and to add color
to the black areas. Add red-orange
and medium orange as you get to mid
values, then yellow-orange.

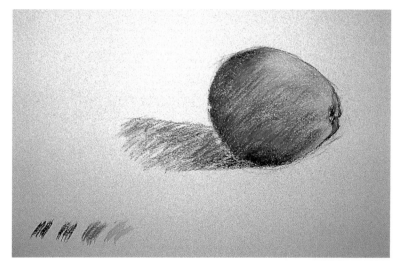

Step back and evaluate your work
so far. (Sometimes it helps to take a
break and come back with a fresh
eye.) Determine the colors with which
the painting needs to be reinforced.

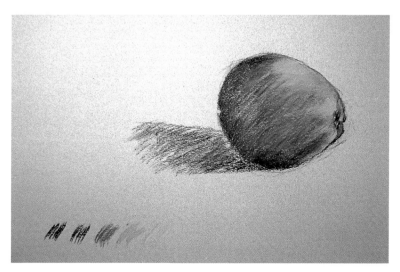

Steps 7: Added Layers. Reinforcing colors where necessary, begin painting from dark to light with medium-soft pastels, starting with medium-dark blue, and red-orange.

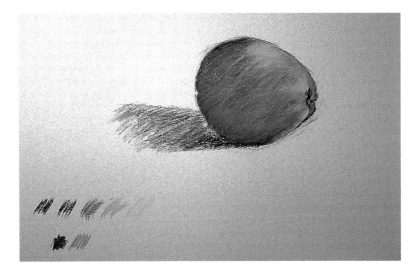

Steps 8: More Layers. Now add the last four colors: medium orange, medium yellow, light yellow-green, and very light blue, which appears almost white.

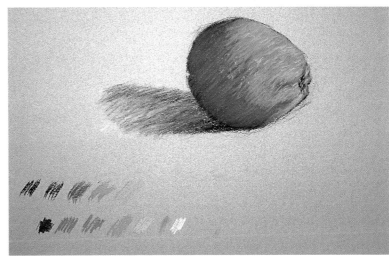

Step 9: Background and Final Accents. Use a combination of the three blues used in the orange for the background, applying them from dark to light. As the complementary color of orange, blue will help make the subject stand out visually. Using lively strokes of blue around the orange also lends a sense of action to a still-life subject.

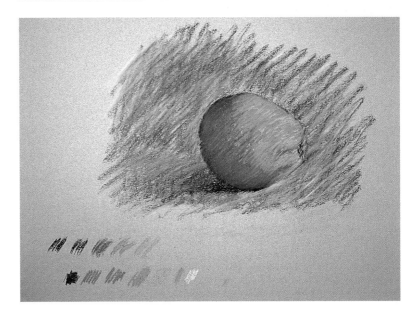

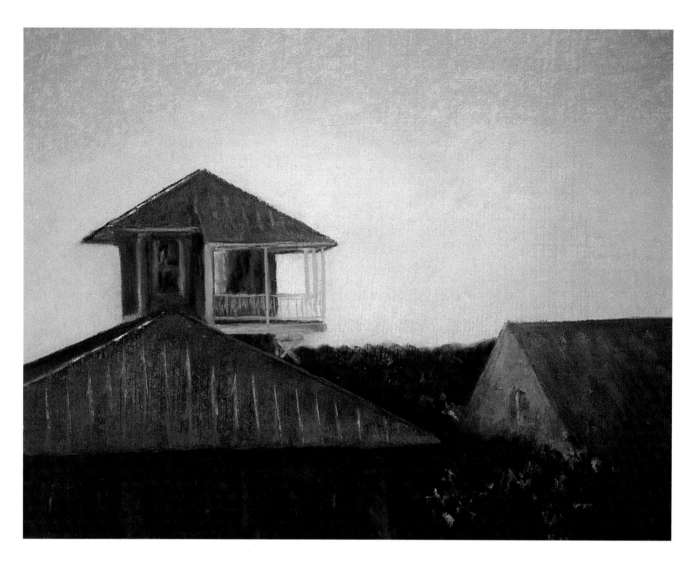

Above: **Tower**
Pastel on granular board, 15 x 20" (38 x 51 cm).
Collection of artist.
Reflected sunset light plays an important role here, painted in hues of orange on the tower's porch, tips of surrounding foliage, and peak of another building. These variations of orange contrast with the blues of the sky and rooftops, adding to the power of the painting's simple composition.

Left: **Sunset Over Marshes** (detail)
Pastel on granular board, 16 x 30" (41 x 77 cm).
Private collection.
Here, careful control of light and dark values defines the clouds, giving them a convincing, three-dimensional appearance. Some of the red marsh colors are incorporated into the cloud formations, leaving no doubt what the main subject is.

Right: **Blue**
Pastel on granular board,
13 x 18" (33 x 46 cm).
Collection of artist.
*Optical mixing accounts for some of the
fiery autumnal hues seen here.*

Below: **Boothbay Bouquet**
Pastel on pastel paper,
13 x 17" (33 x 41 cm).
Collection of artist.
*Fresh strokes of color make visual sense
out of the thriving mass of foliage in
this scene. Direction of strokes is
important when defining subtle differ-
ences in vegetation of similar colors.*

4 |

BLOCK-IN TECHNIQUES

"Big Brush"

In the previous chapter, we explored how to paint with pastels using the broad *tips* of sticks. Now we're going to use the broad *sides* of the sticks for blocking in larger areas of color.

Since the resulting wide swaths are similar to wide strokes made using big brushes with wet media, I call blocking in the "big brush" technique. The materials you will need for these exercises are listed opposite.

In preparation, if you use round pastel sticks for block-in techniques, you may find it easier to flatten the side of the sticks on fine sandpaper.

This shaving of pastel sticks is also helpful when working with certain brands that seem to have a hard coating that must be broken into to get to the soft pastel inside.

Materials
- *plastic gloves*
- *pastels: 1 each (medium-soft) medium blue, yellow, white, orange, dark blue, and (hard) black*
- *pastel paper*
- *vine charcoal*
- *kneaded eraser*
- *rag*

Opposite: **View of Gay Head I**
Pastel on granular board, 22 x 17½" (56 x 45 cm).
Private collection.

Exercise: Wide Marks

Break off a one-inch piece of medium-blue pastel stick. Drawing with its broad side, use *medium* pressure to make a short, wide mark, in whatever direction is natural to you, and repeat several times.

Next to it, make another group in the same way, using *light* pressure, Next to that, make another group in the same way, using *heavy* pressure.

Obviously, painting with the side of a stick covers more area faster than the tip of a stick, and produces even swaths of color, instead of lines. Pressure on the stick determines the color's intensity.

For extra practice, use your favorite color and paint short and long swaths with varying pressure. Make some strokes while pressing down harder on one end of the broad stick, then the other, and note the interesting results.

Exercise: Even Coverage

Draw two rectangles with your medium-blue pastel. Using *light* pressure, block in the first rectangle with the side of the pastel stick. To get even, seamless coverage, with no stripes of color, apply vertical strokes first, then go over them with horizontal strokes.

Do the same in the second rectangle, but use *heavy* pressure. Observe how different the two blocked-in results are, although both were made with the same pastel stick.

The first shows thin, even coverage of blue, with some paper color peeking through; the second shows heavy, even coverage of blue, with less-discernible paper color.

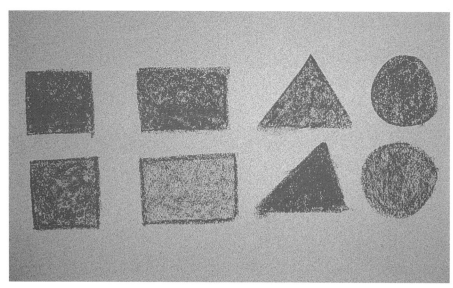

Also notice that the direction of blocked-in strokes made with the side of a pastel stick is less evident than when made with the tip of a pastel stick.

For extra practice, draw a square, rectangle, trian-gle, and circle. Block in the shapes with your favorite color, giving each even coverage. Blocking in various shapes evenly helps the pastelist develop good stick control.

Exercise: Varied Pressure

Using medium-blue, draw four rectangles and block in the first two using light pressure, the last two using heavy pressure. Now apply yellow pastel over blue in the first and third rectangles, using light pressure; then apply yellow over blue in the second and fourth rectangles, using heavy pressure.

Looking at the four rectangles, it's apparant that they are quite different, although they were all painted with the same two colors. Obviously, the rectangles with the heavily blocked-in blue appear the bluest; those blocked-in lightly appear the least blue. The same pertains to the yellow, of course.

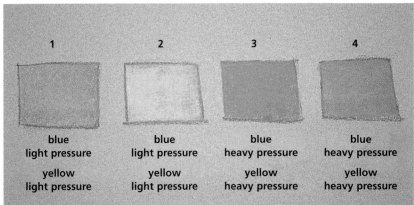

Conclusion: The resulting blend depends upon how much of each color is used and the amount of pressure applied. For extra practice, try the blue and yellow in other combinations and measure your results.

Exercise: Color Order

Draw four yellow rectangles. Using light pressure, block in the first two with yellow; using heavy pressure, block in the last two with yellow. Using light pressure, layer blue over the first and third rectangles; using heavy pressure, layer blue over the second and fourth rectangles.

Compare these four rectangles with one another and with the four of the previous exercise, and you'll see that different pressures and layering orders produce blends that look different. Identify the most yellow and the

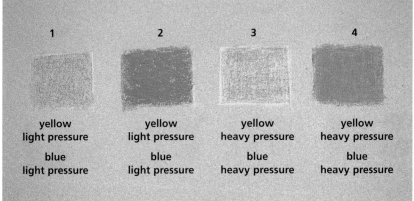

most blue in this and the previous exercise. Also note that darker colors are more opaque than lighter colors.

Exercise: Opaque Coverage, Black-White Scale

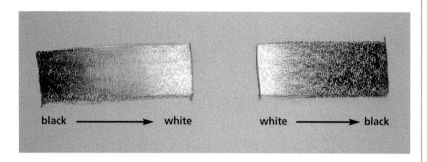

black ⟶ white white ⟶ black

This is similar to the black-white scale in the previous chapter, but here, the block-in technique requires layering vertical strokes over horizontal for more opaque, even coverage. Begin by drawing two long rectangles with vine charcoal, and lighten them by flicking with a clean rag. Block in a gradual transition of color from black to white, painting horizontally with the black first. Start at the left end and, using heavy pressure, drag the stick toward the right, lightening the pressure as you go; stop short of the extreme right. Repeat these horizontal strokes as needed, then block in over them vertically to achieve a seamless look. Repeat, in reverse, with the white pastel, wiping the pastel stick between strokes. Then paint the second rectangle, using white first, then black.

When you step back to check your work, the first rectangle should be pure black on the left, and pure white on the right, with a smooth gradation of gray tones between the two. Even though only black and white make up both groups, the second rectangle's midsection will have a darker, more dominating gray and perhaps a chalky look. That's because painting darks first, overlayed with lights, allows for better color control and avoids the chalky look that darks over lights may produce. For extra practice, try transition scales with other combinations of two colors.

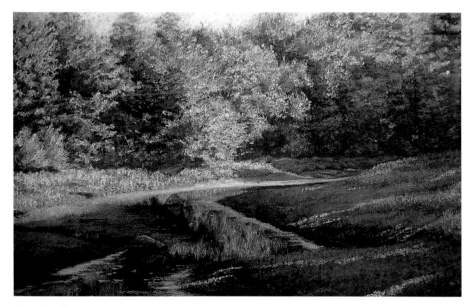

Satucket Sun
Pastel on granular board, 30 x 38½" (77 x 99 cm).
Collection of artist.
Both abrupt and gradual color transitions give this painting a very natural look. The many close variations of green were achieved by varying stick pressure and by observing the effects of color order.

Exercise: Three-Dimensional Look

Draw a circle with vine charcoal, and lighten by flicking it with a clean rag, then block it in completely with orange. Add three more vine-charcoal circles next to the first and lighten.

Block in the second circle with color transitions from orange near the rim to yellow, and then to white in the center. Strive to obtain good color transitions by varying stick pressures. Paint the third circle in the same manner, but start with a light block-in of dark blue near the rim, followed with orange over the blue, and farther into the center, paint yellow and white transitions. Paint the fourth circle in the same way, substituting black, very lightly, for the dark blue.

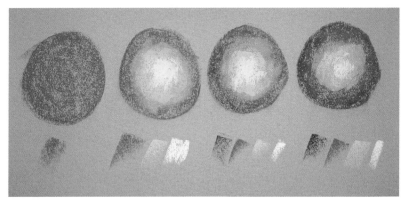

Studying all four circles, observe that the first is a flat orange. The second, with blocked-in orange, yellow, and white, should look slightly three-dimensional. The third, with blocked-in dark blue as the darkest value, should look even more three-dimensional. When layers of dark blue and orange combine to make a dark orange, the resulting color is darker than the darkest color, orange, used in the second circle. If you were able to control the black well enough, the fourth circle should look the most like a sphere, since the dark resulting from black under the orange is darker than the dark blue-orange combination in circle three. For extra practice, create more spheres using your own dark-to-light color combinations.

Exercise: Varied Widths

Pastel artists may not need brushes, but how you paint with a stick of pastel can be likened to brushwork. Make wide swaths with the broad side of your pastel stick. Paint with the broad tip of the stick to produce narrower strokes. Use the stick's fine tip to create the thinnest lines you might need in a painting.

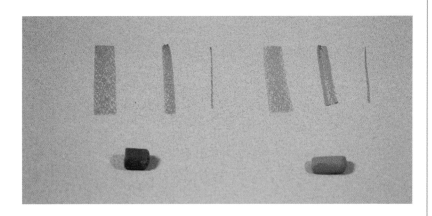

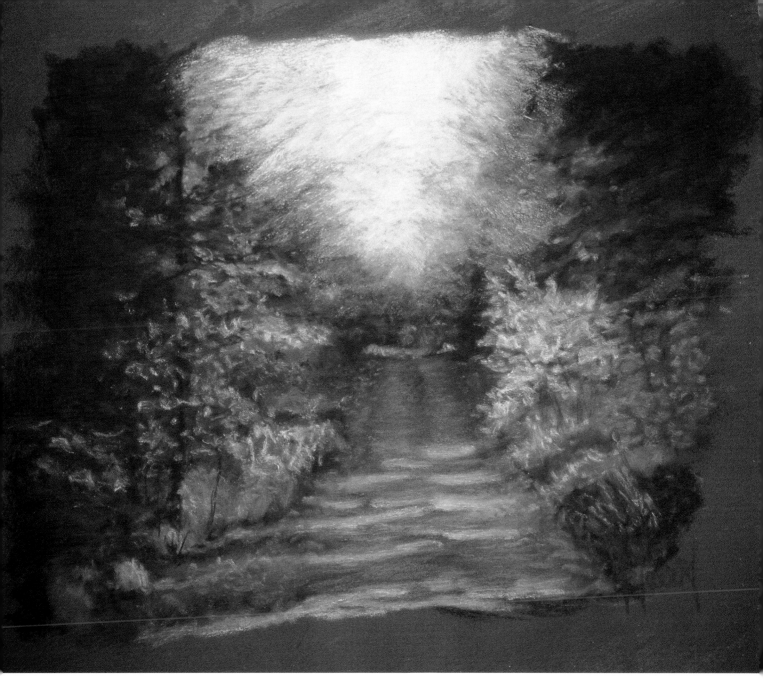

Through the Looking Fence I
Pastel on pastel paper, 12 x 16" (31 x 41 cm).
Private collection.

*Achieving good depth on a flat painting surface requires careful place-
ment of dark and light values. Here, NuPastel black and dark green,
plus a medium-soft dark purple established the dark areas first. I used
very light blue, pink, yellow-green, and light orange last, placed with
care on and along the road and in the sky to further enhance the appear-
ance of distance in this loosely rendered painting.*

DEMONSTRATION:
Blocked-In Red-Green Apple

As in the previous chapter, where your first pastel painting was of an orange, again we'll work with a piece of fruit. This time, choose a multihued apple to depict.

Step 1: Setup. Using light-gray paper as a backdrop, I set up three apples to choose from. The center one, red-green, will be my choice. As with my setup, when you arrange yours, direct one strong light on your apple, and another on your work area. The pastel paper on your drawing board, behind your sketchbook, should match the light-gray paper under and behind the apple still-life setup.

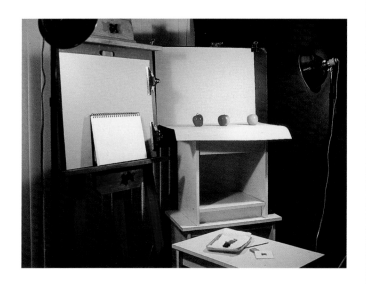

Steps 2, 3: Value Sketch. With vine charcoal, sketch the apple in your sketchbook, and create the dark-to-light, five-value key to guide your drawing. This sketch is a map to give you the apple's outline, the general shapes within the apple, and their placement. As you sketch, emphasize the darks and lights. Place your sketch where you will be able to see it when you begin working on your pastel painting.

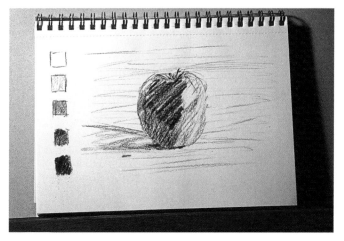

Now you are ready to work on pastel paper. Study your subject and choose your palette of hard pastels according to the colors you see in the apple. There are many: black, dark green, dark blue, dark red, medium orange, medium red, orange, yellow-green, yellow-orange, light pink, and light green. Later, softer pastels will be added to the palette in the final steps of the demonstration. Place your pastel sticks on a paper towel on your worktable, arranged from dark to light.

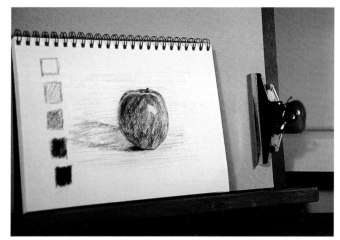

Step 4: Initial Color Block-In.
Using vine charcoal, "ghost" an
outline of the apple on your light-
gray pastel paper, then with your
three darkest hard pastels,
NuPastel black, dark green, and
blue, begin blocking in the darkest
values in light layers, wherever
you find the very darkest areas of
the apple. Vary pressure on the
sticks to create a variety of dark
areas that will serve to darken
other colors, as they in turn are
layered over them. Do not paint
heavy layers of black; they are dif-
ficult to manage later.

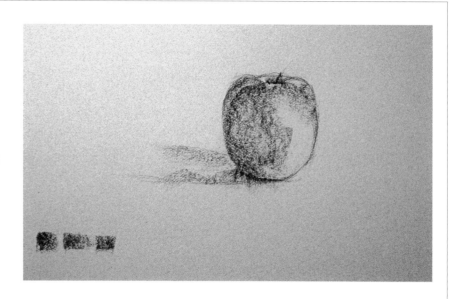

**Step 5: Add Mid and Light
Values.** Six more colors are added
to your palette: dark red, dark yel-
low-ochre, medium red, orange,
yellow-green, and light pink.
Continue to paint from dark to
light, color by color, in light layers,
wherever you see those colors.
Stop just before getting to the
lightest highlight colors, which
come later. As you block in, some
layers of color are placed over
other colors and some are not.
Layering colors is what allows you
to achieve natural-looking color
transitions. Now prepare to use
some softer pastels, starting with
dark blue, now added to your
palette.

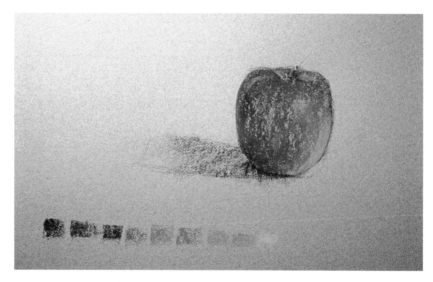

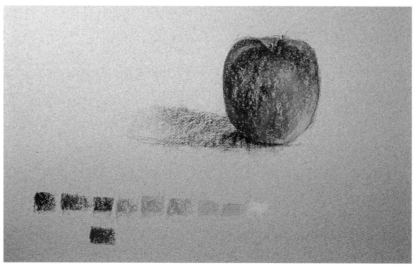

Step 6: Add Softer Pastels. Reevaluate your painting and begin using softer pastels. As illustrated, the softer-pastel colors, shown in swatches under the hard-pastel colors, are matched to them, and a medium yellow is added to the palette. In applying softer pastels, start with the darkest color and decide where you may need more of it to make the apple look more and more contoured and realistic. Then reinforce the mid-value colors and, finally, the lightest.

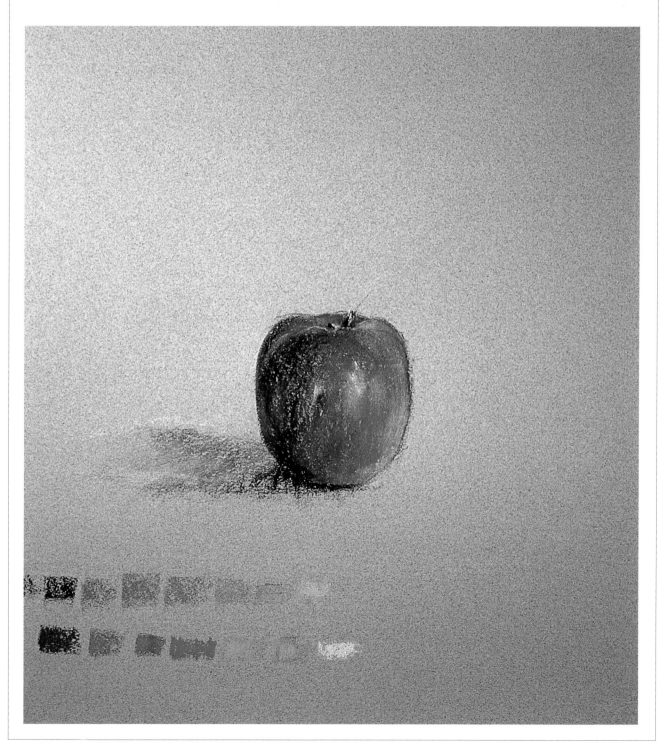

Step 7: Background and Accents. After blocking in every color you see, excluding the very lightest, take a visual break. Not looking at your painting for five or ten minutes will make it easier to pick out any areas that need more work. When you resume painting, now add highlights and background. Choosing a green background—a medium-soft dark green that was used before—will tend to "pop" the apple forward, since green and red are complementary colors. Block in the background loosely, bringing it slightly into the apple.

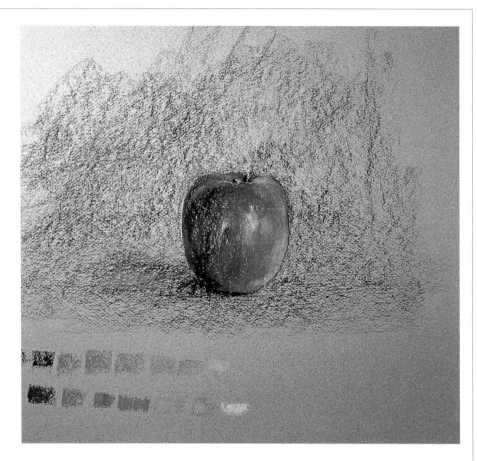

Step 8: Completed Painting. To finish your apple, repaint its edges over the encroaching background to create a seamless visual meeting between the two, then, use very light yellow to create the shine on the apple.

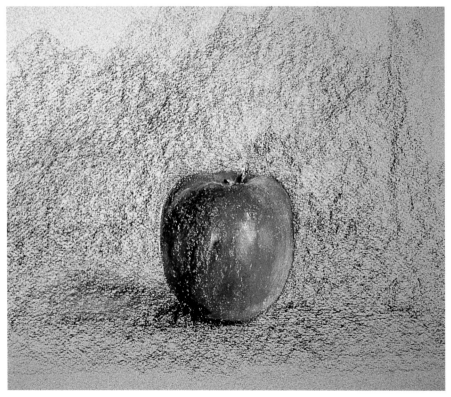

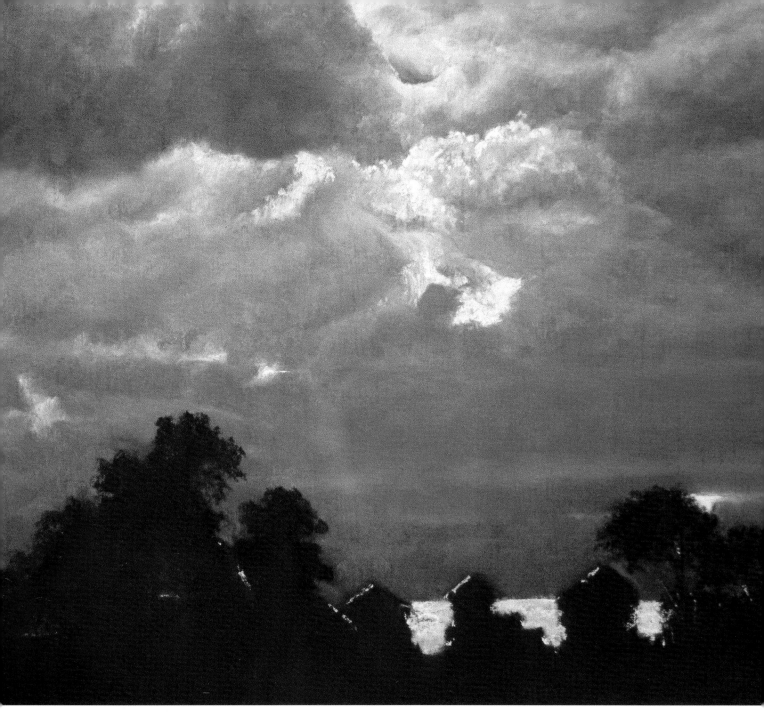

Carillon Silhouette (detail)
Pastel on granular board, 18¼ x 27½" (46 x 69 cm).
Collection of artist.
Even though the area in silhouette is very dark, I painted it
with colors other than black, which were used in the sky,
imparting a unified and lively look.

Opposite above: **Sunset Over Marshes**
Pastel on granular board, 16 x 30" (41 x 77 cm).
Private collection.
I painted these voluminous clouds, peaceful sky, and
contrasting marshes, using the block-in technique
almost exclusively.

Opposite below: **L'Isola**
Pastel on granular board, 13½ x 22" (35 x 56 cm).
Collection of artist.

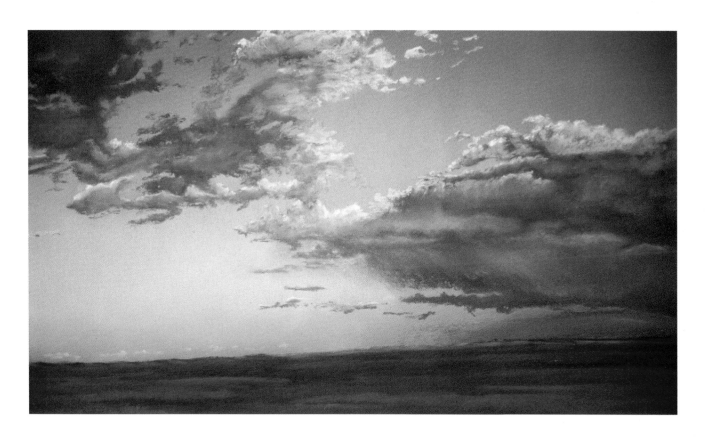

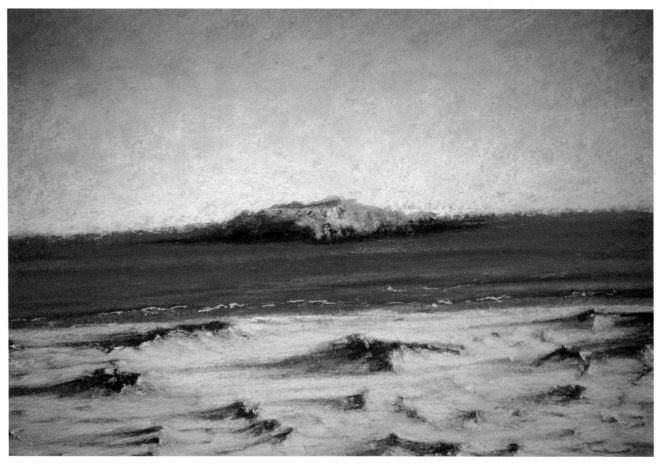

5 | BLENDING AND CORRECTING

To Blend or Not to Blend

Blending pastel colors together is fun. Because it is, the flip side of the coin is that many pastelists use blending as the solution to any painting problem—but it isn't always the right choice to make. Therefore, it is important to know how to blend and when it is a useful tool—and when it is not.

The next exercises illustrate those points. First, assemble the materials you will need for this chapter.

Materials

- *plastic gloves*
- *pastel: 1 each (medium-soft) medium blue and yellow*
- *pastel paper*
- *vine charcoal*
- *kneaded eraser*
- *blender (tortillon or stump)*
- *fine sandpaper*
- *rag*
- *bristle brush (medium)*

Opposite: **Snowfall**
Pastel on pastel paper, 17¾ x 10½" (45 x 27 cm).
Private collection.

Exercise: Blended, Not Blended

With vine charcoal, draw four rows of two circles each; label column one *Blended,* column two *Not Blended.* "Ghost" the charcoal with your rag. Fill in the top two circles with blue closed strokes, using medium pressure; label them *1 color, closed strokes.* Fill row two with blocked-in blue pastel, using medium pressure; label them *1 color, blocked-in.* With the clean tip of your gloved finger, rub the blue circles in the "Blended" column of both rows. Use medium pressure, rubbing in a circular motion.

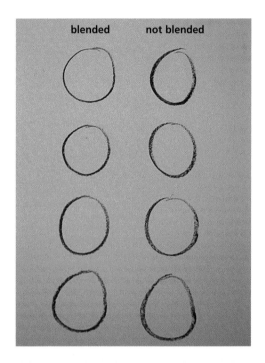

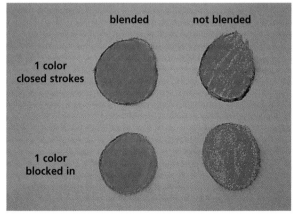

Back up and study the difference between the blended and not-blended circles. Note how the blended color still retains some preblended identity—strokes of color—and that the paper's surface color is not as evident beneath blended pastel.

With your blue pastel stick, using medium pressure each time, fill both circles in row three with closed strokes, then paint a second layer over them with closed strokes of yellow pastel. With your blue pastel, use blocked-in strokes to fill the two circles of row four, then apply blocked-in strokes of yellow over them. With your gloved finger, blend the circles in the "Blended" column of rows three and four.

Step back to look at the four rows, but first note the greenish pastel residue on your glove's blending finger (blending takes away pastel). You should see that slightly greenish tinge on the last four circles. Also notice that the blended circles look different from the unblended. The blended closed-stroke circles also look different from the blended blocked-in circles. The optical mixing effect of the unblended two-color circles differs from the effect given by the finger-blended two-color circles.

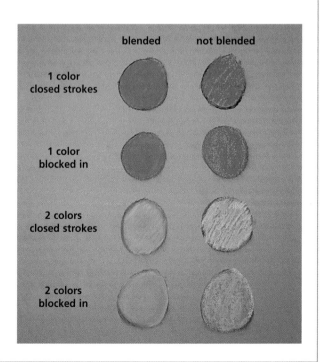

Exercise: Ongoing Blending

Choose a blended circle from the previous exercise and blend half of it again, using a vertical motion, wiping off your blending finger at times. In this manner, continue to blend the same area for three full minutes. That length of time may be tedious, but there's a point to be made: Pastel can be smudged continually and the particles can be spread around, as seen in the blending that overlaps the circle.

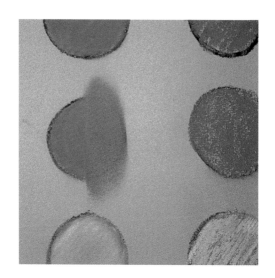

Exercise: Blending Too Soon

Draw two circles with vine charcoal and "ghost" them. Using blue pastel stick with very light pressure, fill the first with open strokes, the second with blocked-in strokes. Blend both circles with your gloved finger.

When you step back to see the results, observe the paper color peeking through both circles. You should see the open strokes of the first circle, as opposed to the fuller coverage of the blended ones in the previous exercises. Here, very light pressure produces less coverage. Conclusion: There must be a sufficient quantity of pastel on the surface to be blended, if you are going to blend effectively.

Choosing Not to Blend

Even though pastel is a very forgiving medium, it is still possible to ruin a painting with a muddy or chalky look, which might occur through overblending. To avoid that problem, ask yourself before you blend why you really need to in that part of the painting. If you can't give a valid answer to that question, don't blend.

In addition to the fact that blending may dull colors, another reason not to blend is to let individual strokes show, rather than be merged with others. You may also want to let more paper color show through by not blending.

Avoid Overpainting

The cure for overpainting—that is, painting without an organized approach—is the same as the cure for overblending: Paint consistently from dark to light. That doesn't mean that you should never paint dark colors over light colors, just that you should not make doing that a routine practice, and should try to organize your painting procedure to apply dark colors first, then medium colors, then light colors.

Exercise: Blended Black-White Transition

Draw one long rectangle with vine charcoal and "ghost" it with a clean rag. Block in a gradual transition of black and white, starting at left with moving to a medium gray in the center, then to white. Now blend the rectangle carefully, preserving the color transition.

As you examine your work, as compared with the black-white exercises in previous chapters, it becomes obvious that this scale's blending creates a smoother look.

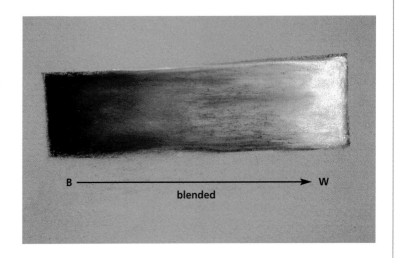

B ⟶ W
blended

Shovel Shop Pond
Pastel on granular board, 13 x 18" (33 x 46 cm).
Private collection.

Selective blending contributes to this painting's warm and serene aura. I worked the sky and water in similar colors, then blended, while leaving the shoreline's last layer fresh and unblended. The hint of morning mist on the pond was added at the end when I lightly dragged and scumbled sticks of very light blue and pink over the blended water, leaving those strokes unblended.

Exercise: Four Different Blending Tools

Draw a long rectangle with vine charcoal and "ghost" it with a clean rag, Apply blocked-in blue pastel evenly with heavy pressure. Draw three vertical charcoal lines, dividing the rectangle into four equal sections. Blend the first section evenly with your gloved finger; the second with your blending stump; the third with your rag (over the tip of your index finger); the fourth with your bristle brush.

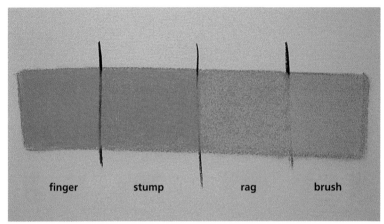

You may have noticed pastel dust falling when blending with the stump. However, also notice how much easier it was to blend the corners of the second section with the stump, compared with blending corners of the first section with your finger—so one conclusion to draw from this exercise is: Use a stump when blending small or irregularly shaped areas. Another conclusion to draw: The blending tool and the amount of pressure you apply to it determines how much pastel remains, thereby affecting its tonal value.

Exercise: Erasing

Continue blending half of each section with its tool for about two more minutes, then try erasing those areas—but take care not to damage the paper's surface. When you try to erase for an extended period after blending, either you smudge the remaining pastel, or erase it to the paper color. Don't be surprised if you do not manage to erase easily. It all depends upon the brand of pastel, the type surface, the blending tool, and how much pressure is exerted. And this exercise is with only one layer of pastel! Referring to the photo, we can see the degree of erasing that resulted over

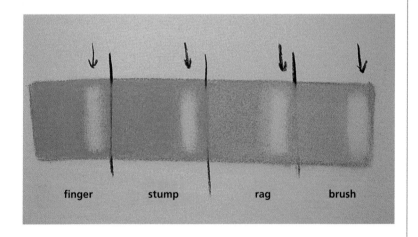

each of the four sections that had been blended with finger, stump, rag, and brush.

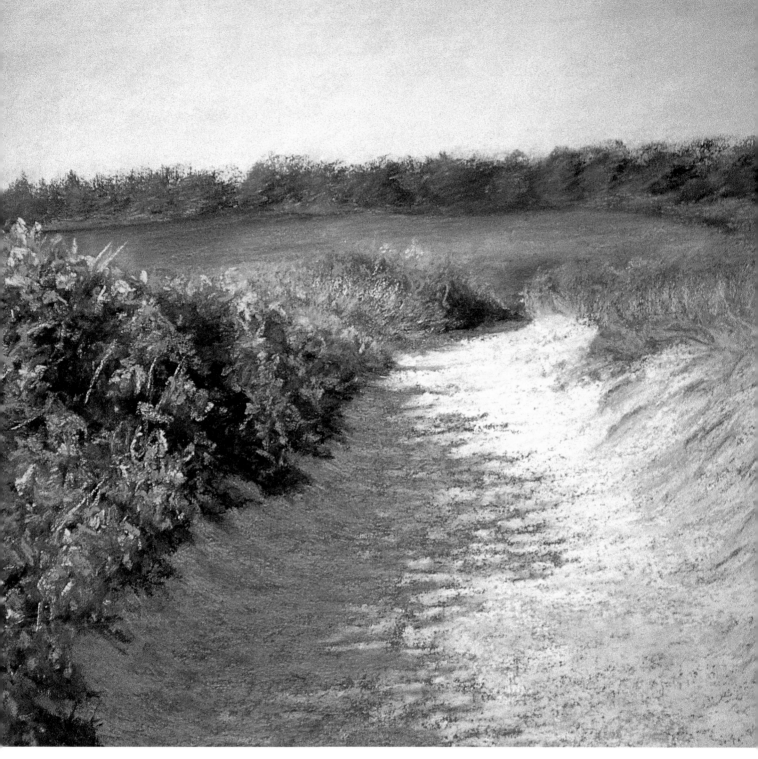

Beach Path II (detail)
Pastel on granular board, 13½ x 20½" (35 x 52 cm).
Private collection.
The absence of blending in the left foreground vegetation adds important accents and details that help describe the wild underbrush.

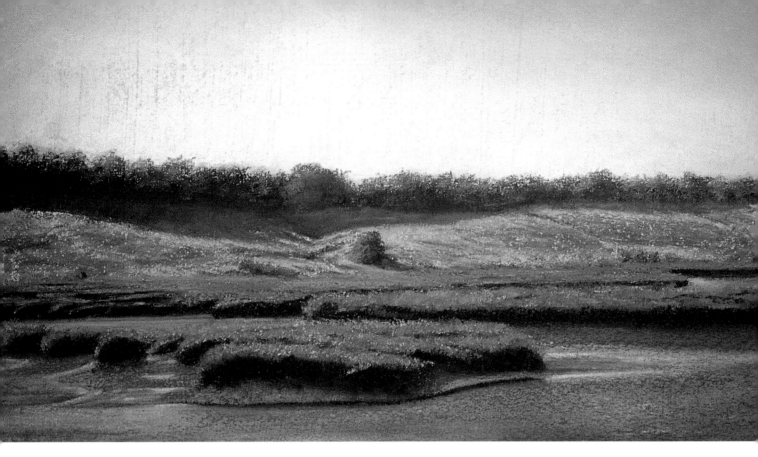

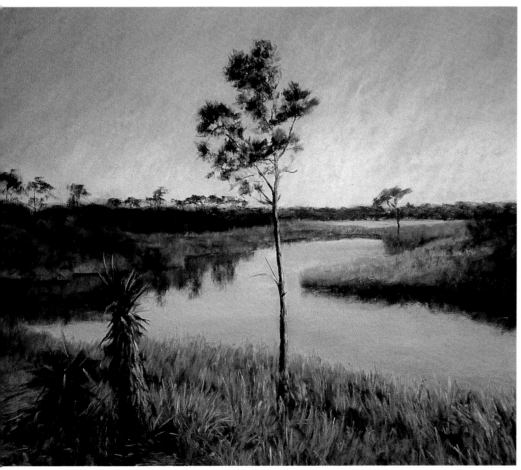

Above: **Sheepscot I**
Pastel on granular board, 9 x 18"
(23 x 46 cm).
Private collection.
Textural differences in the ripples on still water were painted here by lightly dragging a stick of medium-soft, dark-blue pastel over the previously blended water. Blues in the sky were also scumbled over the back tree line, then lightly touched with a fingertip to soften the textural pattern.

Left: **Grayton Beach II**
Pastel on pastel paper, 16 x 21"
(31 x 54 cm).
Collection of artist.
I enhanced the still water and grassy banks in this scene by blending layers of pastel in the water, while building up unblended layers over blended in the grass areas. The sky and water were both painted "into" the large foreground trees. Then, with a bristle brush, I removed most of the stray sky/water pastel from the tree area, and painted the large palm tree.

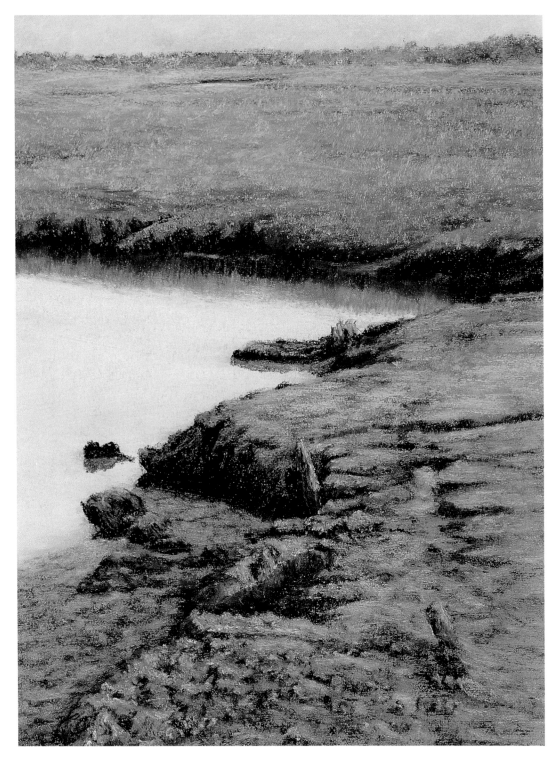

Mud-Flat Sundown
Pastel on granular board, 20¼ x 12¾" (52 x 53 cm).
Collection of artist.
I heightened the contrast of land and water in this scene by blending the light blues and light oranges of the water, while leaving the subdued colors of the land unblended.

Correcting Mistakes

For me, one of the most endearing qualities of pastel is how "forgiving" it is—that is, how easy it is to correct. Knowing that almost any mistake can be overcome takes away the burden of having to be right with every single stroke. The following exercises illustrate the basics of correcting errors. If you have not done the previous blending exercise, however, I suggest that you go back and do so, since understanding how to correct errors is the logical sequel to understanding blending.

Exercise: Blocked-in; No Brush, With Brush

Without drawing outlines, paint two yellow, heavy-pressure, blocked-in circles. Rim the first with blue pastel by painting over stray ends of yellow. Adjust the outline of the second circle by using a bristle brush to flick off as much of the stray ends of yellow as you can, than paint over that rim with blue. Notice that it was easier to correct the second circle's edges by getting rid of some yellow first, then covering it with blue. Thus, you can correct mistakes by painting over them.

no brush with brush

Exercise: Closed Strokes, No Brush, With Brush

Without drawing outlines, paint two yellow, heavy-pressure, closed-stroke circles. Rim the first with blue pastel by painting over stray ends of yellow. Adjust the outline of the second circle by using a bristle brush to flick off as much of the stray ends of yellow as you can, than paint over that rim with blue. As the previous exercise also showed, here again, removing pastel first makes it easier to apply another color over it—whether working with blocked-in application, as in the previous exercise, or with closed strokes, as here.

no brush with brush

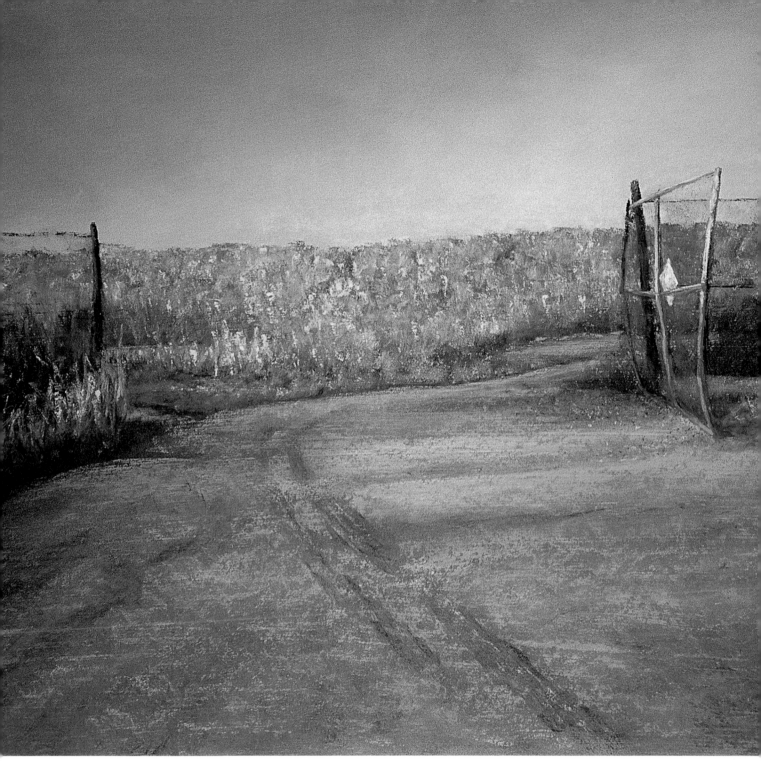

Gateway
Pastel on granular board, 13 x 19½" (33 x 50 cm).
Collection of artist.
This rich palette was built up by blocking in a base layer of colors
with hard and medium-soft pastels, blending, then painting the
final, unblended layers with medium-soft and very-soft pastels.

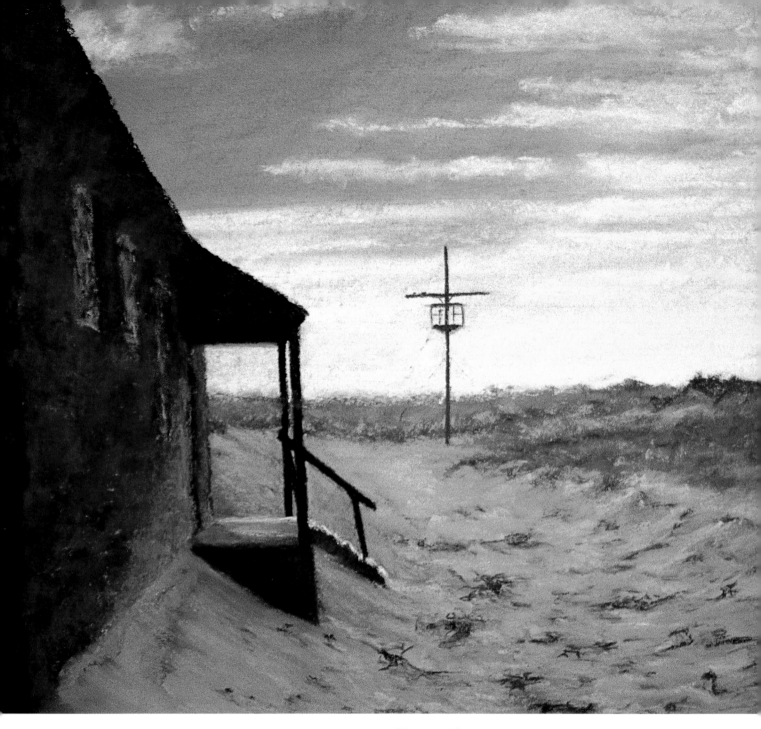

Observatory I
Pastel on granular board, 14½ x 25½" (40 x 65 cm).
Collection of artist.

My initial painting of this subject had a crosslike structure in the distance, as seen here. But as time went on, I realized that even though I knew that structure was a nesting area for birds, most viewers saw it as a religious symbol. So I decided to paint out that misinterpretation—a correction that the forgiving pastel medium would allow.

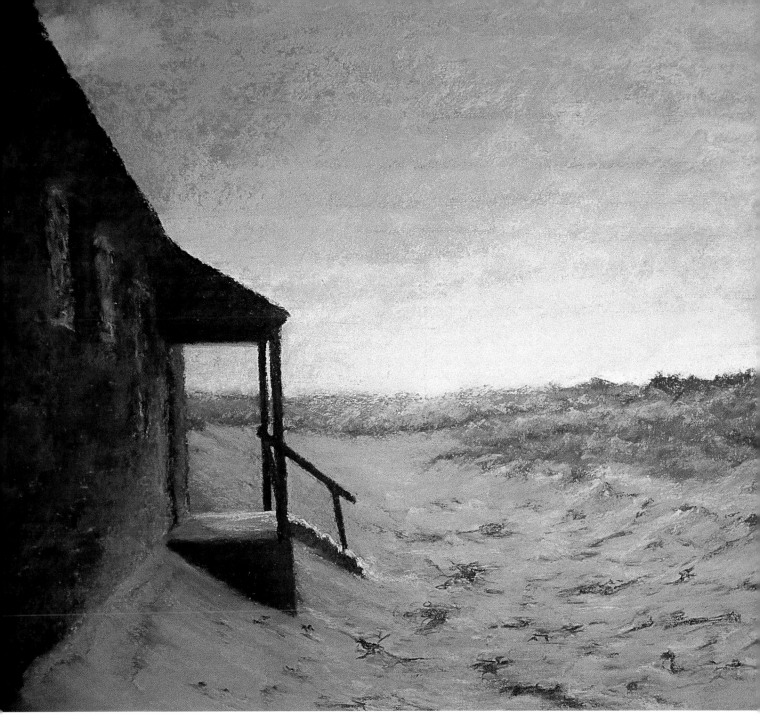

Observatory II
Pastel on granular board, 14½ x 25½" (40 x 65 cm).
Collection of artist.
After brushing off as much pastel as I could, then painting the area and changing the sky a bit, the nesting structure is gone, and the painting is the better for it.

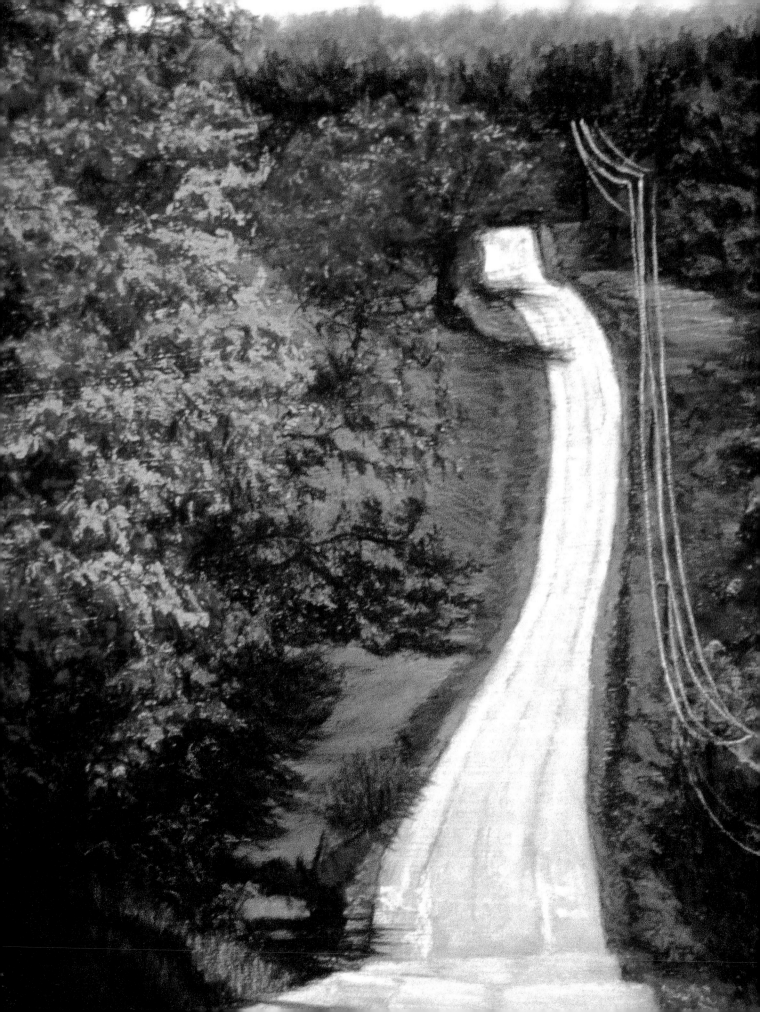

6 | COMBINING TECHNIQUES

Achieving Varied Effects

We have now seen and practiced basic techniques: painting with closed and open strokes, blocking in, and blending. Oftentimes, artists combine these techniques in the same painting to achieve varied effects. Let's try it. First, assemble the materials you will need.

Materials
- *plastic gloves*
- *pastels: 1 each (medium-soft) medium blue and yellow*
- *pastel paper*
- *vine charcoal*
- *kneaded eraser*
- *rag*

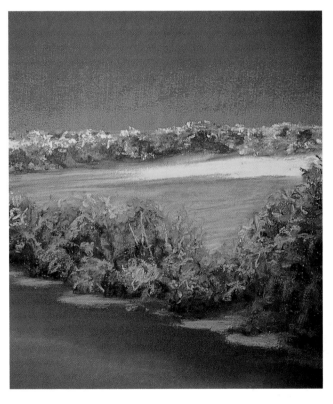

Opposite: **Ribbon Road**
Pastel on granular board, 13 x 21" (84 x 54 cm).
Private collection.

Above: **Meadows** (detail)
Pastel on granular board, 8½ x 14½" (22 x 37 cm).
Private collection.

Exercise: Layering in Different Ways

Draw four rectangles with vine charcoal and "ghost" them with your clean rag. Fill the first two rectangles with blocked-in blue, using heavy pressure. Fill the last two rectangles with blocked-in blue, using light pressure. With yellow pastel, layer rectangles one and three with closed strokes over the blocked-in blue. Then layer rectangles two and four with yellow open strokes over the blue.

Compare your results in this exercise with two earlier yellow-over-blue exercises: "Color Order" (page 36) and "Varied Pressure" (page 50). All of the rectangles involved have heavy applications of blue, followed by heavy applications of yellow. How do they compare to one another? Which one looks the yellowest, and why do you suppose that is?

With careful observation, you'll find the answer: Closed-stroke application puts down more pastel than the heavy-pressure, blocked-in technique. It can also be concluded that it is easier to control an even application of pastel using the blocked-in technique than it is using the open-stroke technique. For extra practice, use a different blue and yellow to see how varied your results can be.

| closed yellow over blue | open yellow over blue | closed yellow over blue | open yellow over blue |
| blocked in heavy pressure | blocked in heavy pressure | blocked in light pressure | blocked in light pressure |

Exercise: Selective Blending

Draw two rectangles with vine charcoal and "ghost." them. Use the blocked-in technique in both rectangles—first blue, layered over with yellow. Blend the second rectangle only. Then layer blocked-in blue and yellow over both rectangles again.

Examine your work. The two rectangles were painted with the same colors, yet they look a bit different, due to selective blending and layering. Which has the freshest-looking color? Which looks as if it were painted on green paper? It appears that by blending the last layer, colors look less

fresh than they could. Blending initial layers creates a custom-colored base that may enhance subsequent layers.

Still-Life Setups

Still lifes are the best painting subjects for beginners in any medium. Since the objects are physically present, unlike photographed landscape, for instance, all the visual information is right in front of you. If it is your chosen still-life—as opposed to a classroom setup—you have complete control over the items, arrangement, background, lighting, and colors. To prepare for your first still life, here are some tips.

Choosing Items

Begin with still-life items that have uncomplicated shapes—boxes, balls, simple vases—or long-lasting fruit and vegetables that will remain fresh during your painting sessions. Select things that have special personal meaning—perhaps antique boxes from your collection—since they may be more fun to paint and hold your interest longer while you work. Also consider color. Stay away from pure black or white objects for your first still lifes, as it is harder to see a lively palette in them. Choose objects whose colors complement one another, or choose objects of the same or similar hue.

Choosing Background

Colored mat board or a solid-colored swatch of cloth placed behind and under a still-life setup are the easiest backgrounds to paint. Sheets, towels, bedspreads, and scarves can be enlisted to serve as background. If you want to avoid painting folds and crumpled fabric, keep the material taut. I buy fabric remnants in various solid colors and textures. If you do the same and keep several colors on hand to choose from, you can experiment with different backgrounds before selecting the one that suits the subject best. In general, backgrounds should have secondary importance to still-life objects and not dominate them.

Below: The simple shapes of a mortar and pestle make good still-life subjects for the beginner pastelist. Here are three different background possibilities for this simple setup. Which background color do you think makes the best setting for this subject?

Choosing Perspective

There are many variables in vantage point when setting up a still life. Instead of just looking at what you're going to paint from your sitting or standing position, consider raising the still life to your eye level so you're looking straight at the items, or lowering them to give you an aerial view. Walk around the arrangement and consider one of its side views. A different way of looking at common items often makes the difference between an uninteresting painting and a dynamite one.

Arranging Lighting

Lighting is a critical element in still-life painting. Wonderful daylight is always preferable, but not very practical unless you plan to paint quickly or for brief periods at the same time of day over several days—under the same fine weather conditions.

The artificial alternatives to natural light are many. The simplest and most usual method is to direct one main light to illuminate the still-life setup. Another way is to position a second, weaker light on the objects from another direction. Try different light placements to decide on the best for your chosen objects.

Eliminate all other sources of light that interfere with getting the effect you want. Be sure that lights coming from another source won't compromise the careful shadow effects you're trying to capture by lighting the subject from one side only, having a long cast shadow become an important part of your painting's design. Therefore, in most cases, the best lighting may mean that you have just one light on the still life and another on your easel and table area only.

Produce I
Pastel on pastel paper, 8 x 12" (20 x 31 cm).
Collection the artist.
The interesting shapes of my husband's garden cucumbers worked well in this simple setting, with the choice of a warm background color to complement the greens.

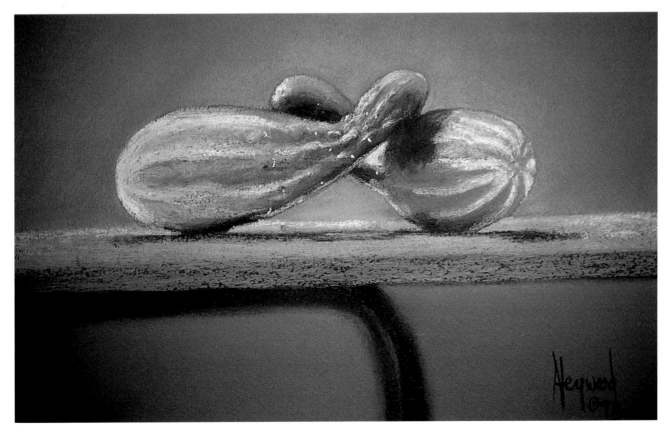

Venetian Privacy II
Pastel on granular board, 18½ x 28½" (47 x 72cm).
Collection of artist.

*For the more experienced pastelist, an ordinary bathroom sink,
accessorized with a few mundane objects, makes a complex and
compelling still life, enhanced further by the unusual lighting effect
of daylight filtered through a window blind, casting interesting
shadows over the scene.*

DEMONSTRATION:
Still Life, Melon and Lemon

We've worked with only one piece of fruit in each of the two previous demonstrations. Now, slices of two different fruits present a more complex challenge.

Step 1: Setup and Value Sketch. Begin by arranging your still-life objects on a background that will show them off nicely. Here, both the melon and lemon colors stand out beautifully against their warm background drapery. Illuminate your setup with one light and your easel with another. Then with charcoal, make a small sketch of your still life in your sketchbook, to explore shapes, placement, and values of the objects. Now, and not later, is the time to change any of these, before you begin working on pastel paper and painting with colors.

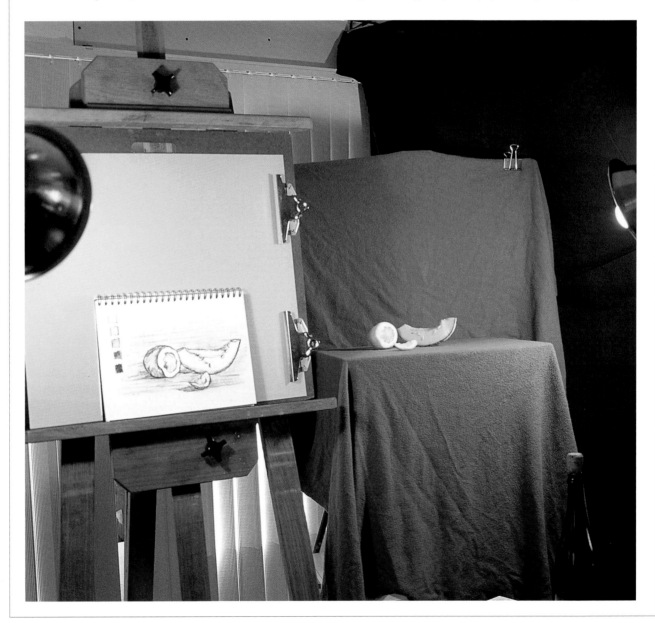

Step 2: Block In Darks First. Once satisfied with your sketch, begin working on your painting surface— here, an ochre pastel paper to harmonize with the melon and lemon colors. After sketching with vine charcoal, begin blocking in the first light layers of darks: black, dark green, and dark blue. These and other colors used initially are hard NuPastels. Softer pastels will be added to the palette in later steps.

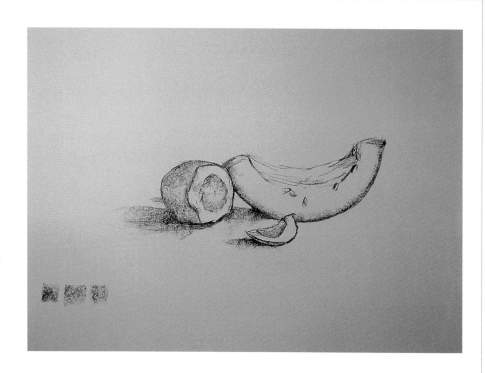

Step 3: Add Medium Values. Continue blocking in with light layers of pastel, working in a dark-to-light manner. The colors introduced here are medium-dark olive green and deep orange. Work all over the painting, observing the subject carefully and referring to your black-and-white sketch for value placement. For a loosely blocked-in background, use both the green and orange in light layers.

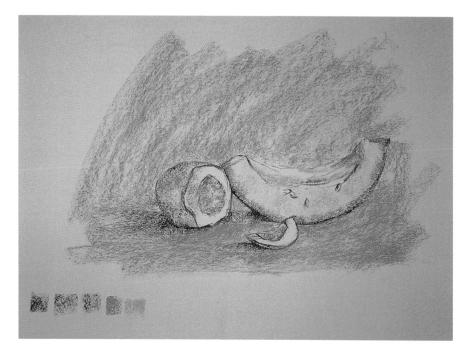

Step 4: Add Light Values.
Blocked-in light orange, medium yellow, and light yellow come next. Blend carefully with your gloved fingertip to eliminate paper "holes"—areas that pastel particles missed. Blending will push the colors around, dull them a bit, and give your still life a smoother look. Many more layers of colors are coming, and any future blending will be minimal so as to preserve color impact.

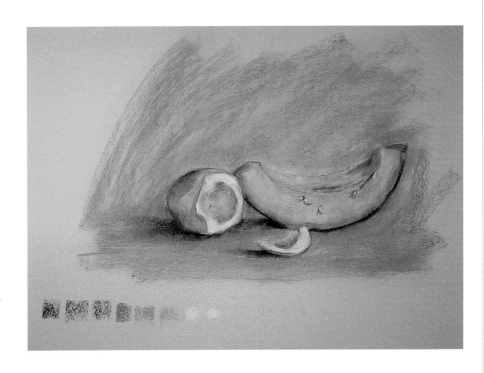

Step 5: Reinforce Color with Softer Pastels. Still blocking in, reinforce from dark to light with hard pastels, and introduce some softer pastels in dark and medium green, red-orange, orange, and in yellows—medium, light, and very light. Continue to layer, stopping to reevaluate as you go.

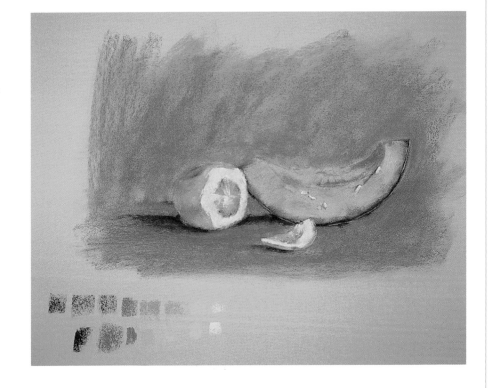

Step 6: Final Accents. Reinforce the background colors as needed, then work on details—melon seeds, lemon rind, and highlights, using the broad tip of your pastel stick where it fits easily, and the fine tip in smaller areas. Vary your strokes, using the techniques described earlier. If you care to frame your still life, crop away the color scale, as shown. Another choice would be to crop out the color scale, but leave some bare paper showing all around as a sort of self-mat.

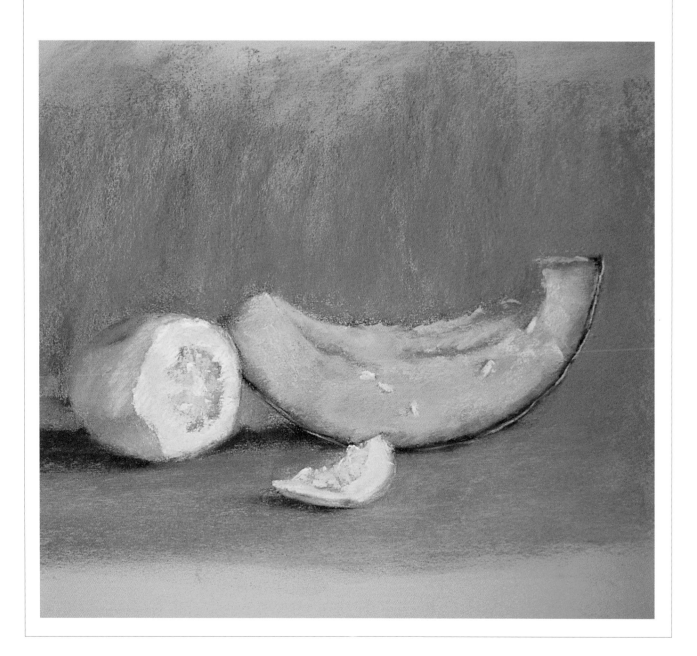

About Fixative

I deliberately did not include fixative in my "Materials" chapter because I do not usually endorse its use. However, since some pastelists do spray fixative on their finished work, if you should want to experiment with it, here is some basic guidance.

What is pastel fixative? Generally speaking, it is a liquid sprayed on a pastel painting to make the pastel particles adhere more permanently to the surface. Of the many fixatives on the market, some are in aerosol form, others are pump or atomizer sprays. Any fixative that can be used with pastels will be labeled as such.

Artists typically use pastel fixative on a completed painting, but it can also be used during the painting process to adhere layers of pastel, darken areas of a painting, or to re-create a workable surface when the painting no longer accepts pastel because the tooth of the paper has been filled or damaged. Those last two instances are the only reasons why I personally would use fixative—and only by spraying it out of doors.

Does fixative make pastels impervious to smudging? Many centuries of experimentation still have not developed a fixative that will render a pastel painting incapable of being smudged, while preserving its original colors.

Use Fixative with Caution

There are several reasons why I avoid fixatives. First, fixative is not good for your health. It must be used with extreme caution—and never sprayed indoors. Follow the manufacturer's directions carefully, and avoid breathing in fixative fumes; even "odorless" fixatives should not be inhaled.

Second, fixative is unpredictable. I once used it on a finished painting, only to have the aerosol spray permanent polka dots of fixative all over my work, even though I had just cleaned the spray nozzle.

Third, fixative changes pastel colors. I'd rather not use fixative to alter a painting's colors—I can alter them myself with pastels.

Finally, pastel particles will fall over time, even from "fixed" paintings. I usually paint my work on heavily textured surfaces that hold pastel particles better than less-textured surfaces.

Over the years, however, I have also done many paintings on pastel paper, and they are still fixative-free and alive today.

Opposite: **End of Day** (detail)
Pastel on granular board, 12 x 17½" (31 x 45 cm).
Collection of artist.
The suggestion of bright, blinding sunlight coming through the sky was achieved by surrounding that area with soft edges that contrast with the sharper silhouette of the dark treeline below.

Above: **Duo**
Pastel on granular board, 25 x 37" (64 x 95 cm).
Collection of artist.
Both blocked-in and open-stroke applications contribute energy
to this combined-technique painting.

Opposite: **Ebb**
Pastel on granular board, 20 x 16" (51 x 41 cm).
Collection of artist.
Here, the foreground rigid brambles conrast with the limp,
blowing grass on top of the dune. A sense of wind and changing
tide is conveyed by the small area of water lapping into the
scene.

7 | TEXTURE

Depicting Tactile Qualities

With flashy videos, commercials, and print ads that often focus on greatly enlarged details, our modern eyes are accustomed to seeing objects in tight close-up where we can observe their surface textures—their tactile qualitites. Painting texture, therefore, is naturally lots of fun, since textures are details. The soft fuzz on a peach, grasses in a field, the fur on a dog's face—all are easy-to-see textures that add up to the illusion of a three-dimensional object on a two-dimensional surface—which is the key to creating a realistic painting.

I've saved discussion of texture for this far into the book for the very reason that textures should be painted last. If you were to try a hair-by-hair approach in depicting animal fur, or a blade-by-blade approach to a grassy field, the result would be a belabored, unsuccessful painting with a man-made look, not at

Opposite: **Walk in the Woods II**
Pastel on granular board, 45 x 35"o (115 x 90 cm).
Private collection.

Materials
- *plastic gloves*
- *pastel: 1 each (medium-soft) medium-blue and yellow*
- *pastel paper*
- *vine charcoal*
- *kneaded eraser*
- *rag*

all convincing as resembling nature's growth. But when textured details are added in moderation—as final touches—they bring heightened reality to a painting.

With experience, pastelists usually develop their own methods of rendering textures. But if you start with the basic texture-making marks of this chapter's instruction, you will be armed with techniques to express a wide range of tactile effects in your pastel work. First, assemble the materials you will need for the exercises ahead.

Exercise: Scumbling

With vine charcoal, draw two circles and "ghost" them. Lightly drag the broad tip of your blue pastel stick over the first circle, using a circular scribbling motion. Keep the stick pressure light, and fill the circle equally with your random circular scribbles. Paint the second circle with blue in the same manner. Then apply yellow over the blue, using those same light, circular, scribbling strokes.

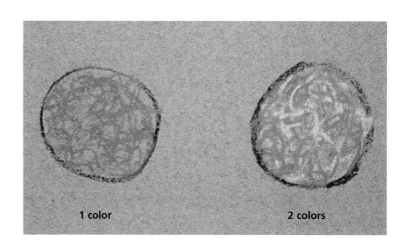

1 color **2 colors**

Exercise: Crosshatching

With vine charcoal, draw two circles and "ghost" them. In the first circle, with the fine tip of your blue pastel stick, make hatch marks—that is, several small, parallel lines with a little space between them, followed by other hatch lines drawn over those at right angles. Continue crosshatching until the entire circle is filled, but allow some paper to show through. In the second circle, paint blue hatch marks crossed by yellow hatch marks.

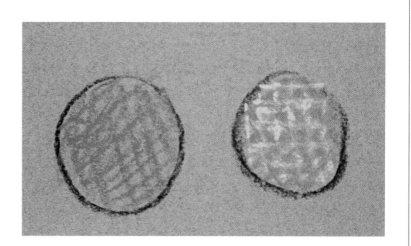

Exercise: Pointillism

With vine charcoal, draw two circles and "ghost" them. Using the broad tip of your blue pastel stick, fill the first circle with blue dots or dashes. Do the same in the second circle, then add yellow dots/dashes over the blue. Your second circle should show lots of blue and yellow and some paper color.

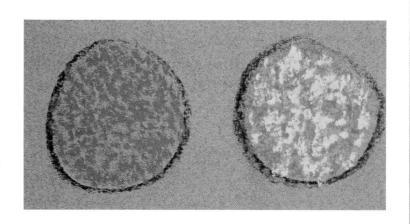

Exercise: Feathering

With vine charcoal, draw two circles and "ghost" them. Using the fine tip of your blue pastel stick, fill the first circle with groups of fine, light lines, going in different directions. Repeat the process in the second circle, using the blue pastel stick, then the yellow.

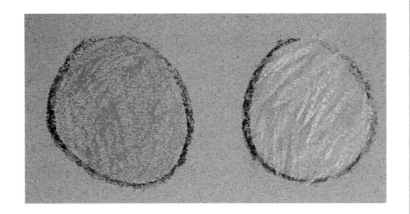

Exercise: Grinding

With vine charcoal, draw two circles and "ghost" them. Break your blue pastel stick to expose an irregular surface at the end of the stick. Using this "raw" end and heavy pressure, repeatedly grind your pastel stick in the first circle. Repeat this procedure in the second circle, using blue first, then yellow.

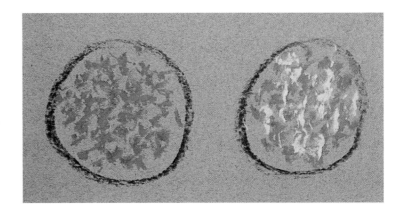

Exercise: Summary

You now have five different textures in one color in column one, and the same five varied textures in two colors in column two.

Study the different effects. Guess which ones would be the most appropriate treatments for rendering peach fuzz in a still life, fog in a landscape, or the texture of dog fur in an animal portrait.

Imagine that instead of applying these treatments to bare paper, you had applied them over other colors.

There are many creative ways to render textures with pastel. For extra practice, paint a small area with red, blend it, then apply another color over it using one of the above texture techniques. Repeat the experiment with other combinations of colors and other texture techniques.

These five different techniques for suggesting texture are merely the tip of the creative iceberg. Why not try your hand at creating some unique textural effects of your own with pastels?

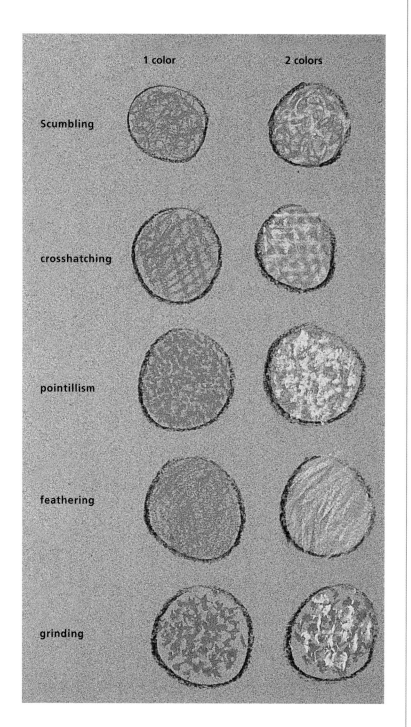

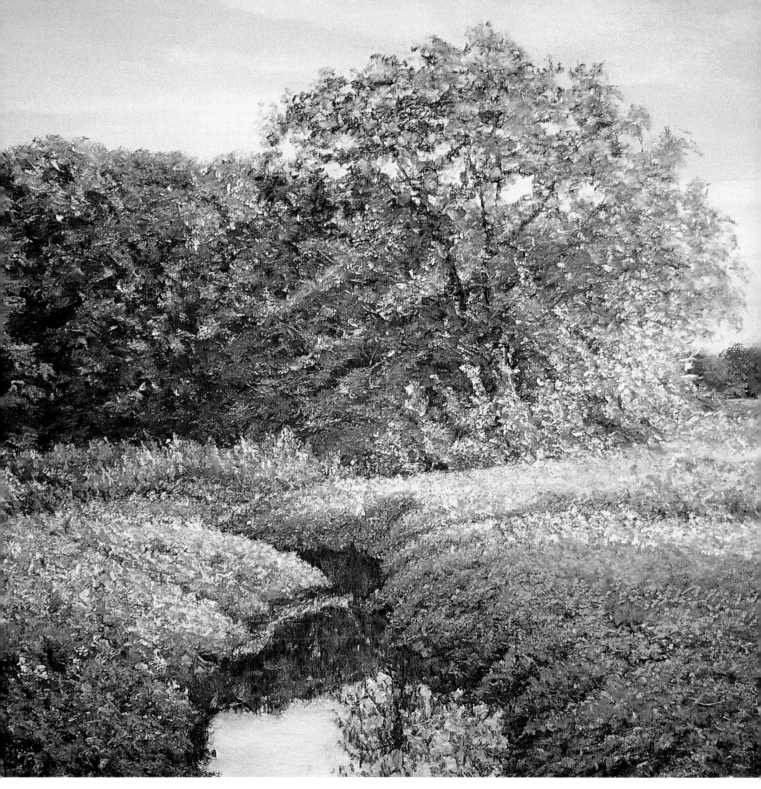

Wetlands Summer (detail)
Pastel on granular board, 23½ x 34" (60 x 87 cm).
Collection of artist.
Pointillism texture played an important role in this painting.

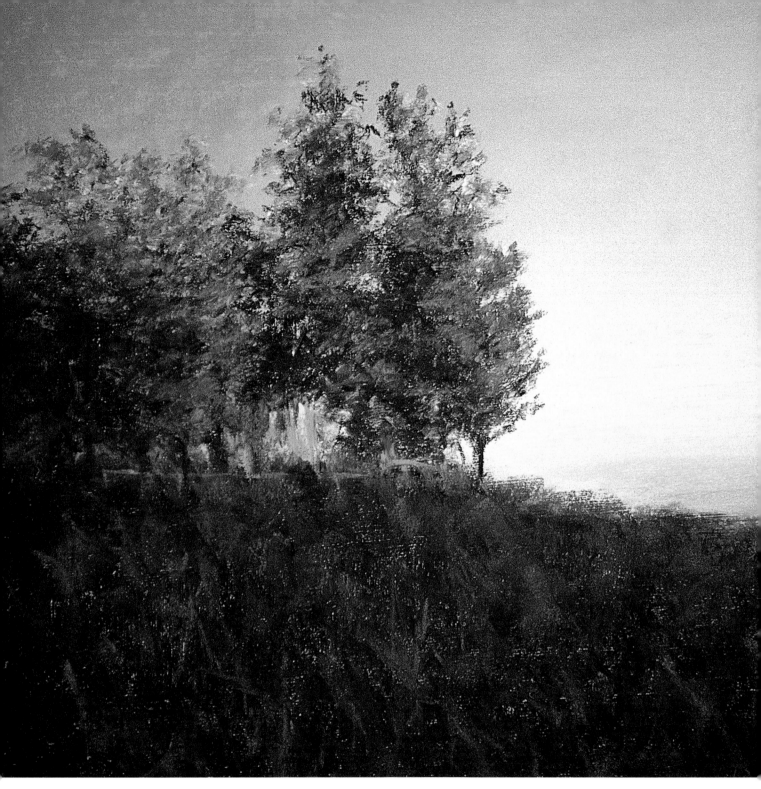

Sunset Home (detail)
Pastel on granular board, 10 x 13¾" (26 x 35 cm).
Collection of artist.
The large foreground field is very dark but still suggests grass due to the texture used. Most of the grass strokes were deliberately aimed toward the house, itself just a few strokes of color, to further enhance the composition.

Camp (detail)
Pastel on granular board, 11 x 17" (28 x 44 cm).
Collection of artist.
*The "Keep Out" on the door is given further importance
with a shallow depth of field, restricted cropping, and
interesting textures achieving by using techniques such as
grinding and scumbling.*

The Meadow (detail)
Pastel on granular board, 30 x 55" (77 x 141 cm).
Collection of artist.
The depth achieved in this large piece is in great part due to differences in texture in foreground, mid ground, and background. The sheep were painted loosely with the "big brush" and positioned to lead the viewer into the distance.

Eleanor's View (detail)
Pastel, watercolor, and charcoal pencil on granular board,
10 x 21" (25 x 54 cm).
Private collection.
A simple scene like this becomes more interesting when textures
are added. Using medium-soft pastels, I lightly feathered and
dragged color over charcoal pencil at the tree line to give more
depth and definition to the shore and its reflection.

8 |

COMPOSITION, COLOR, VALUE

Composing a Painting

Simply stated, composition refers to the organizational structure of a painting. It is how you, the artist, lead your viewers' eyes through your painting. You use many tools in composing a painting, but basically, shapes, lines, and values do all the heavy work.

Form and Content

All paintings are made up of two main components: form and content—the elements that comprise that composition and deliver its message. Without good composition (form), your content, or message, goes nowhere.

Many tried-and-true compositional schemes have come down to us through history. A popular one is the Golden Section, or Golden Mean, which works with a ratio of roughly 5:8 in determining the ideal proportions of a rectangular painting surface, and how

to arrange elements within it. There are also simpler, less mathematical schemes, such as the triangular composition in many classic religious paintings, where the central figure's head is at the apex, or top, of a grouping that is placed in an overall triangular arrangement. Far more complex arrangements are common to huge battle scenes. Today, we tend to be less concerned with formal structure and more interested in the painting's content, or message—but composition is just as important as ever.

Studying Old Masters' paintings is a great way to learn fine composition. Go to a museum with some friends, and play this game: Everyone stands in front of the same painting, closes their eyes, then opens them and looks at the painting. Do this several times. After a few minutes, each of you tells the others how your eyes traveled through the painting. What did you see first? How did your gaze travel from there? Where did your eyes rest? You may be surprised to find that you all traveled along the same route—but that was no accident. Master artists plan compositions to lead viewers in a specific way, to deliver the painting's message— even centuries later—as intended by the artist.

Opposite: **The Way**
Pastel on granular board, 40 x 32" (51 x 38 cm).
Collection of artist.

Finding Your Way to Good Composition

Achieving good composition is partially intuitive and partially learned. Just as some people instinctively know how to arrange furniture in a room, some people are innately talented at composing elements in their paintings. Whether or not you are one of those naturally gifted souls, working hard at developing good composition will prove more rewarding than using instinct alone. Even though I am a good driver, I would no more take a trip somewhere for the first time without directions than I would do an original piece of art without predetermining its composition—my "road directions"—first.

The easiest approach to composing a painting is by seeing its elements "naked"—without the distraction of colors or details. That is accomplished by making small black-and-white sketches first. So, to reiterate the procedure I've described earlier: Use charcoal pencils to sketch, and begin with large, general shapes. For example, in a simple still life of a flower vase on a table, sketch the outline of the vase and general shape of the whole bouquet first. Then add other important larger shapes—perhaps the shadow cast by the vase on the tabletop. After that, shade in general light, dark, and medium values. At this point, although fairly simple and abstract, your sketch should have all the important information you need. Now, it's time to pause and think.

Go back to thinking about your message—the reason that you chose your subject in the first place. What are you trying to express with your painting? Is it the fullness of the flowers? Or maybe the vase is what drew you to the subject, and should catch the viewer's eye first. Would your message be stronger if you change your sketch a bit? Sometimes it actually helps to write down your objective. Even though this is only a simplified black-and-white version of the more complex painting to come, all the basic composition elements —shapes, lines, values—should be there to deliver your message. So explore different solutions, then decide which works best, and use that as reference for your painting's structure. This removes having to make hit-or-miss decisions when you begin working with pastels on your pastel paper.

Left: The development of a composition: What began as a horizontal scene with a bench ended as a vertical scene without a bench, the best composition for the painting being planned.

Opposite: **Hammocks**
Pastel on board,
20 x 16" (51 x 41 cm).
Collection of artist.

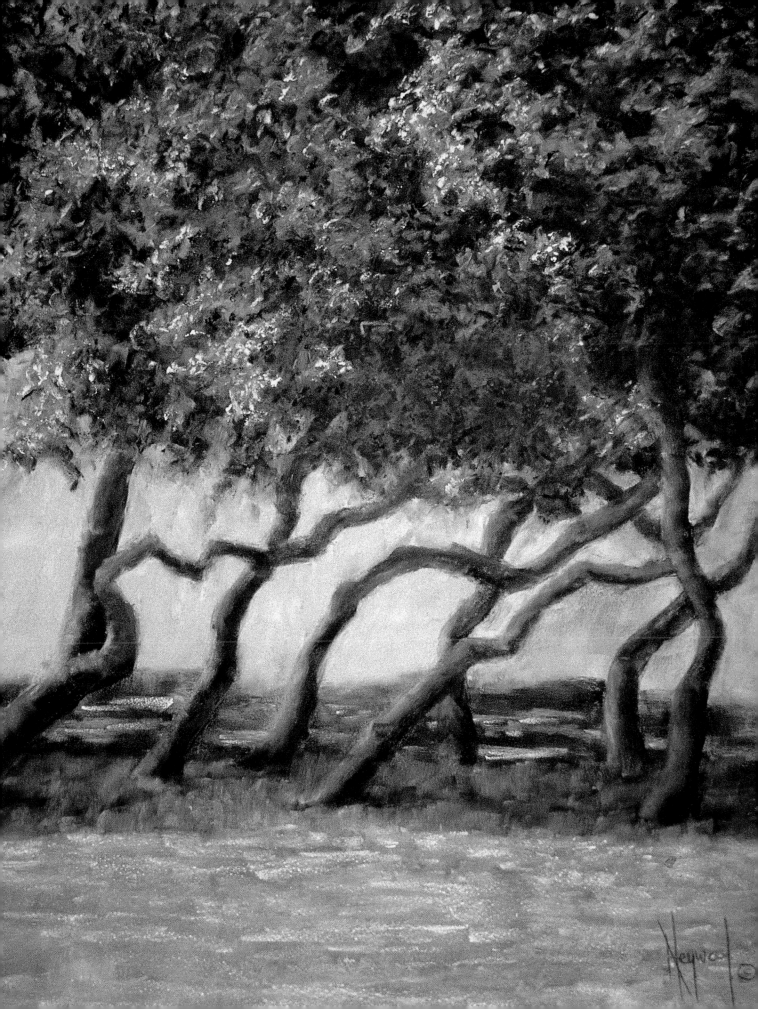

Color Basics

Volumes abound dealing with color methods and theories. Since such advanced instruction is beyond the scope of this book, we will touch only on the basic color classification and terminology that will be helpful to you in selecting colors for your pastel paintings. First, assemble materials for the exercises ahead.

Materials
- *plastic gloves*
- *pastels: assortment of medium-soft plus black (hard) pastel*
- *dinner-size plate*
- *pastel paper*
- *vine charcoal*
- *rag*
- *ruler*

Exercise: Color Wheel

Draw a large circle by tracing around a dinner plate with the vine charcoal. Divide the circle in half vertically, then divide each half into three equal parts. Your circle should now have six equal "pie slices." With your clean rag, "ghost" all charcoal lines.

Now fill in your color wheel, using any painting technique, as long as you obtain even coverage throughout. Working clockwise, begin with yellow, followed by green, blue, purple, red, and orange, as shown. The result is a basic color wheel with three primaries—red, yellow, blue; and between them, the secondary colors—orange, green, and purple—which are made by combining the primaries. Therefore, red plus yellow equals orange; yellow plus blue equals green; red plus blue

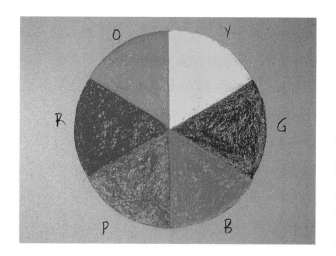

equals purple. Do not leave any blank space between sections, and be sure to get sharp, clean edges.

Color Categories

Referring to the color wheel helps to understand the relationships among colors and certain predictable qualities about them. Information about each color category follows.

Analogous Colors

Any two colors next to each other on the color wheel are analogous, when one of them is a primary. For example, yellow (a primary) and green are analogous, as are yellow and orange; red (a primary) and orange are analogous, as are red and purple; blue (a primary) and green are analogous, as are blue and purple. In other words, analogous colors are those that are the

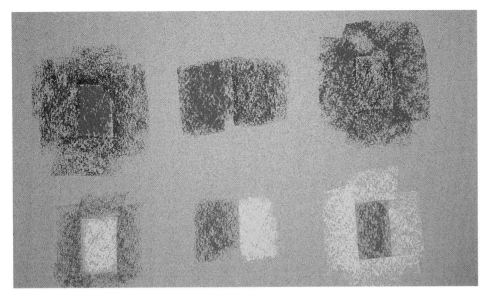

most similar to each other. Therefore, if you place them next to each other in a painting, they will not contrast as much with each other as they would with colors that are not analogous.

Complementary Colors

Any two colors directly opposite each other on the color wheel are complementaries: yellow and purple; red and green; blue and orange. Complementary colors seem to "vibrate" when placed next to each other, one color pushing the other color away visually. If you blend or optically mix a color with a little of its complement, you will dull that first color—a good thing to remember when you are trying to mute a color within a painting.

Neutral Colors

If you continue to add more of a color's complement to it, you will eventually create a neutral color, such as brown or gray. Generally speaking, neutral colors are browns, tans, grays, blacks, whites. (If you blend all of the color wheel's hues together, you will create black.) Pastel manufacturers also provide many interesting blended neutrals, such as green-gray, blue-gray, and other variations.

Cool Colors

Green, blue, and purple are the cool colors on our basic color wheel. Generally speaking, these colors tend to recede, or go back in distance, and seem to lend a calm, peaceful feeling to a painting.

Warm Colors

Red, orange, and yellow are the warm colors on our basic color wheel. As such, these colors tend to advance, or come forward, in a painting. They are fun to use when creating exciting, active moods or subjects.

Exercise: Neighboring Colors Affect Each Other

In order for light colors to look brilliant or dark colors to have depth, they need another color around or nearby to contrast with them. This exercise demonstrates that point.

We begin with three small swatches of four different colors—red, yellow, dark blue, black—laid down on the same piece of paper. Place another color around each of these, and see how each original swatch color takes on a different appearance because of the proximity of its neighboring color.

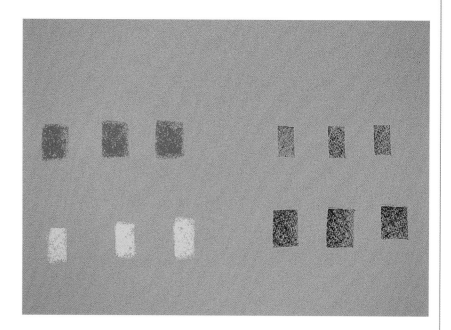

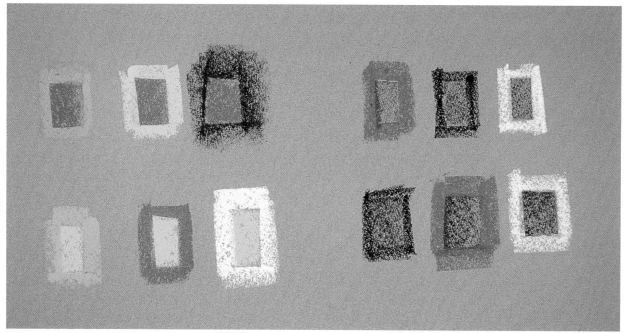

Upper left: Paint orange, yellow, and dark blue around the red swatches. Do the medium-reds look alike any longer?

Lower left: Paint yellow-orange, red, and white around the yellow swatches. Which yellow seems the brightest? Which the least bright?

Upper right: Paint red-orange, black, and white around the dark-blue swatches. In which swatch does the dark blue seem the darkest?

Lower right: Paint black, red-orange, and white around the three black swatches.

Note how one black swatch looks darker than the others, due to contrast.

Translating Values to Colors

One of the more frequent questions I hear as an instructor is, "What colors should I use?" My answer is always, "If you want to make your subject look realistic, it doesn't matter which color you choose—as long as you get the values right." Another question I hear is, "Why does my painting look flat?" Then, too, my answer is always, "You haven't used the proper values."

Up to now, I've reviewed values—the darks, mediums, and lights in a painting—mainly in relation to charcoal sketches, because differences in shading are most easily seen in black and white. But now, we come to value in relation to color—for it is when colors are added to a painting that values become more difficult to see and maintain.

One of the perks to being a "certain" age is being able to remember black-and-white television. Everything looked perfectly realistic without color—only in shades of black, gray, and white. To discern values in colors, you need to make a visual translation of a monotone palette into color, in the same way that viewers of black-and-white television did.

If you made the paintings in our earlier demonstrations—*Orange* in Chapter 3, *Apple* in Chapter 4, *Lemon and Melon* in Chapter 6—viewing one of those from a distance, with your preliminary sketch next to it, will help you to translate values to colors. If you have a computer with a scanner, scanning in a photo of your painting and changing the image to black and white will also clarify the point. The same test can be made with a black-and-white photocopy of a colored painting, rendering it in degrees of value from black to white with many shades of gray in between.

Why is it useful to see values in your painting? Because it allows you to evaluate whether its most important elements are working: composition, modeling, and focal point, which are all affected by your proper control of darks, mediums, and lights. Values can help move the viewer's eyes around a painting, making a flat object look three-dimensional. Values can establish the focal point and create a dynamic composition.

Colors translate easily into black and white with photography, as seen in this range of dark, medium, and light values in each pastel color group.

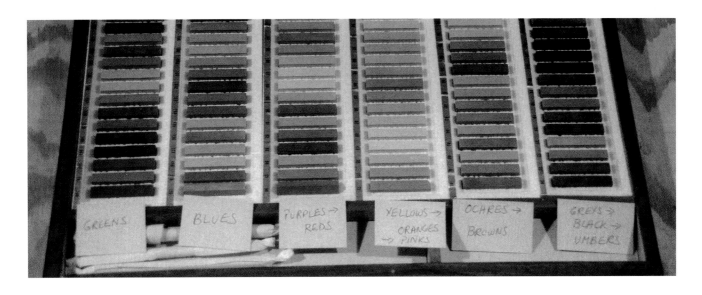

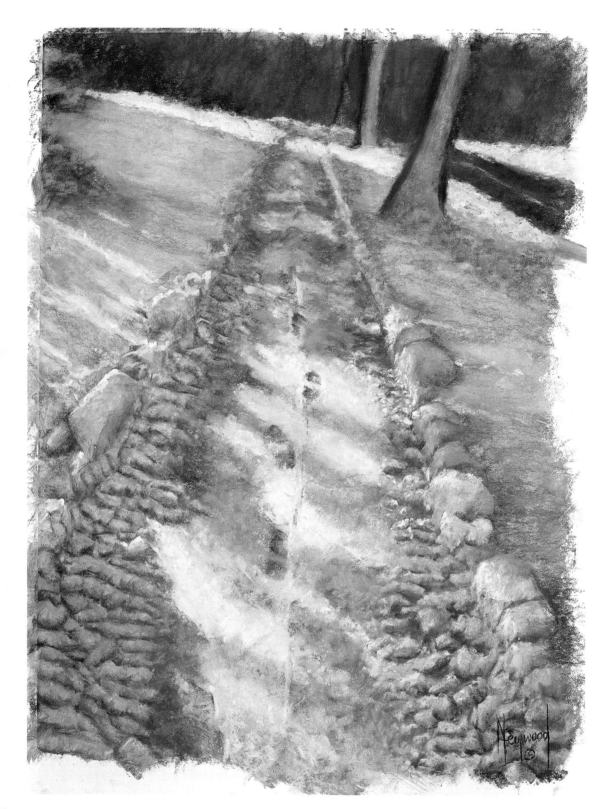

Tracks
Pastel on paper, 20 x 15" (51 x 38 cm).
Collection of artist.
Values are more important than particular colors used when rendering this
pathway, made up of many smaller shapes that describe the clumps of snow.

Opposite: **Path to Fox Hill**
Pastel on watercolor paper, 20 x 15" (51 x 38cm).
Private collection.

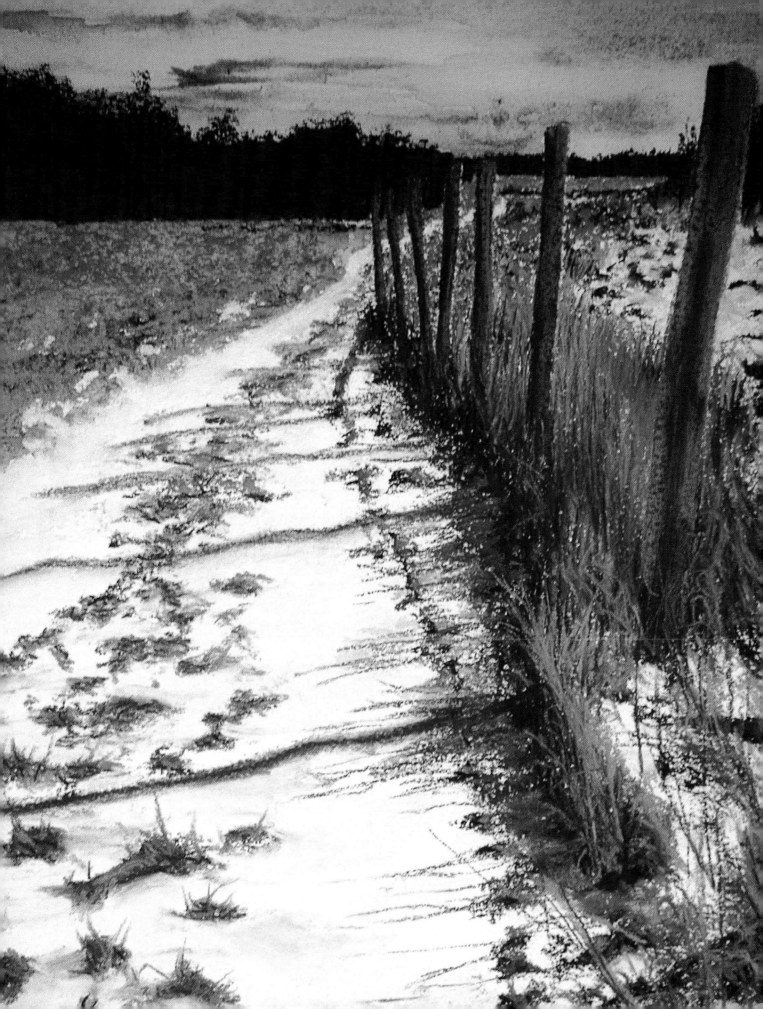

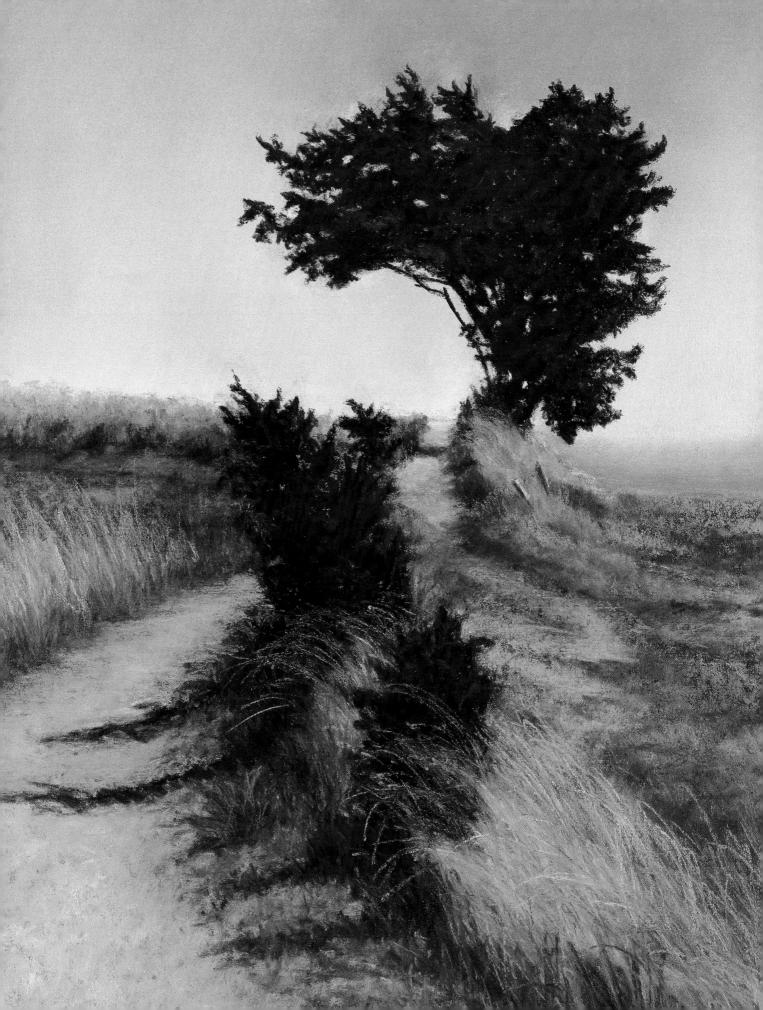

9 |

PAINTING A LANDSCAPE

Choosing Your Subject

Selecting the scene for a pastel landscape can be great fun. Mother Nature provides so much painting material, all you have to do is look around you. With such an abundance of landscape scenes to paint, how do you choose the best one?

Keep It Simple

Don't expect to paint the Grand Canyon right away. Some day you may—but for starters, choose uncomplicated settings, and take many reference photos of them on a sunny day, early in the morning or toward evening, when shadows are longest. When working from photos, order 4"-x-6" or larger prints. If you paint from life, use a viewfinder to set the boundaries of your scene; that is, hold up a small mat or an empty slide mount to isolate your chosen scene visually from its surroundings.

Opposite: **To the Ocean**
Pastel on granular board, 19 x 13" (49 x 33 cm).
Collection of artist.

Avoid Tracing

Every so often, I have a few students who insist they cannot draw, and therefore, should trace. Methods of tracing abound, but while the results may be instant and realistic, the sketch will look stiff. If you are thinking of tracing a picture rather than drawing it yourself, read on.

Painting a realistic landscape does not mean copying every detail of nature. You are not creating a photograph; cameras do that very well! You are creating a personal work of art with your talent, experience, tools, and imagination. If you trace rather than interpret, you will always be locked into whatever photographic image you've chosen. All of your editing options will be gone—such as changing size, shape, or location of objects, and you will be limiting yourself by not putting more of your own personal stamp on your work. So, if you are unhappy with your drawing skills, I encourage you to devote more time to studying drawing. With proper instruction and practice through classes, workshops, and how-to instruction books devoted to drawing, you are sure to improve.

Charcoal Sketches Comes First

The most time-economical way to determine whether the scene you've chosen will make a good painting is to explore it first in the privacy of your sketchbook. Make your black-and-white sketches freely, knowing that no one else will see them.

Establish Shapes

- Locate only the large, main shapes in the scene—no details.
- Reduce those objects to basic geometric forms: circles, squares, rectangles, triangles, which will represent trees, bushes, cliffs, mountains, and so on.
- Use variations or combinations of basic shapes, for example: a rectangle for a tree trunk, topped by a circle for its foliage.
- Locate and sketch in any important smaller shapes. They may be separate shapes or shapes found within the large shapes.

Create a Black-White Value Scale

- Draw five small boxes in the margin of your sketch.
- Fill the boxes evenly with charcoal, varying the pressure to produce a range of tones. Start with the third box, applying medium pressure (dark gray); use heaviest pressure in the fifth box (black); use medium-heavy pressure in the fourth box (a shade between black and dark gray); use medium-light pressure in the second box (light gray); leave the first box blank, to represent white.

Add Values to Your Sketch

- Locate the darkest areas of your scene and shade them to match box five of your value scale.
- Locate the medium-dark areas of your scene and shade them to match box three.
- Locate areas between the darkest and medium-darkest values and shade them to match box four.
- Locate areas between the lightest and the medium-darkest areas and shade those to match box two.
- Leave the lightest parts of your scene blank; the white of the paper will represent those lightest areas of your landscape.

The preceding steps may give you a fairly abstract sketch, but the basic information that you need will be there—where the main, large shapes are located. As you proceed, you may want to go beyond the basic sketch and change the contours, size, or placement of some of your shapes. Whatever you do, however, keep your "thinking on paper" stress-free. If you're not happy with what you see, turn the page in your sketchbook and start over.

After sketching several scenes or variations of the same scene, compare your sketches to see which one appeals to you the most. If you have trouble deciding, choose the simplest one.

DEMONSTRATION:
Afternoon Reflections

Once you've completed your preliminary charcoal sketch, choose the surface that you will use for your finished painting. (Here, I've chosen an ochre-beige pastel paper, because its color is similar to dominant tones in this demonstration's scene.) Affix the paper to your drawing board with clips, tape, and/or elastic bands, and place the board on your easel. Direct a light on your easel and on the worktable that holds your supplies.

Materials
- plastic gloves
- vine charcoal
- clean rag
- pastel paper
- pastel assortment

Step 1: Setup. Place your sketch and its photo reference nearby for ongoing reference as you paint.

Step 2: Sketch and First Color. Sketch the scene on your painting's surface, using vine charcoal. This sketch can be as simple or as detailed as you feel is necessary to create a "map" of your painting. Flick a clean rag over your sketch lightly to remove any excess charcoal; don't overdo it, or all of the sketch will come off. Then paint in the first layer of sky.

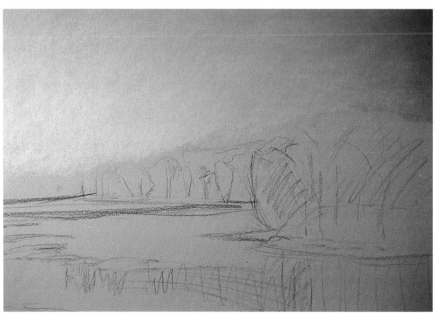

Step 3: "Big Brush" Block-In. The sky in this scene is fairly simple, with richer blues toward the top, slowly transitioning to lighter yellows and blues toward the horizon. Begin blocking in with a hard stick of a very light yellow, adjusting your stroke by adding more pressure toward and slightly below the horizon, and less away from the horizon. Then block in hard pastel in light yellow-ochre just over the top and above that area, adjusting your pressure to give more coverage toward the horizon, and less above it. Next, block in a hard pastel in medium blue, overlapping some of the yellows already applied, and paint well into the rest of the sky. Block in various darker blues in hard pastel, taking care to vary pressure and overlap colors to make a seamless transition of colors in the sky, rather than stripes. Blend lightly with your gloved fingers. Blending gives the sky a smooth look, but will also dull it somewhat. Reinforce its colors by reapplying those that are needed, and bringing in some medium-soft pastels. This time, blend very little or not at all. Now, add the first light layer of colors to depict the blue water and brown swamp grass, using hard pastels.

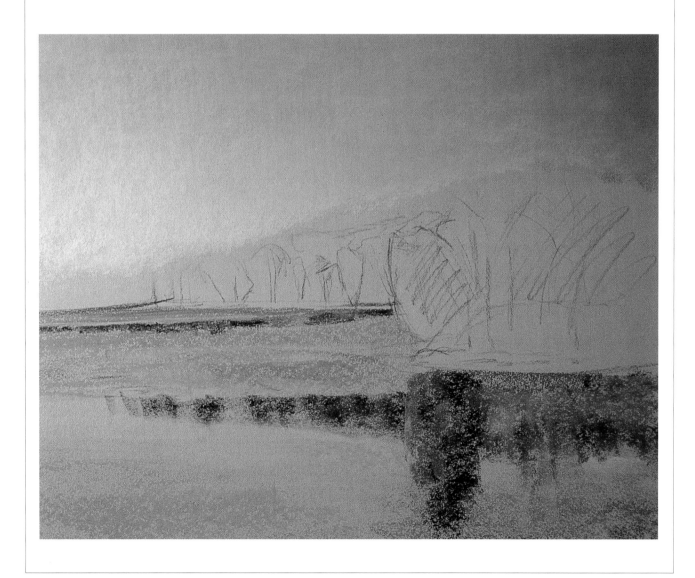

Step 4: Developing Water and Reflection. Paint the water with horizontal strokes, using some of the colors applied to the sky, plus others that you may see in the water that are not in the sky. Observing the general color patterns in the water, paint from dark to light, using darker blues where the water is darker, and variations of blues where you find them in color patterns. Ignore details such as ripples at this point. Paint right over the small areas where there are little islands of swamp grass. For the shore's reflection in the water, use both the "big brush" blocking-in technique and the "medium brush" (broad tip of stick) in horizontal and vertical strokes. (The reflection will be finished later, once the shoreline and tree are established.) Once the general colors are down, blend carefully with gloved fingers. Reinforce colors where necessary, bringing in more colors and medium-soft pastels. Lightly blend some small passages, but, for the most part, avoid blending, which will remove color.

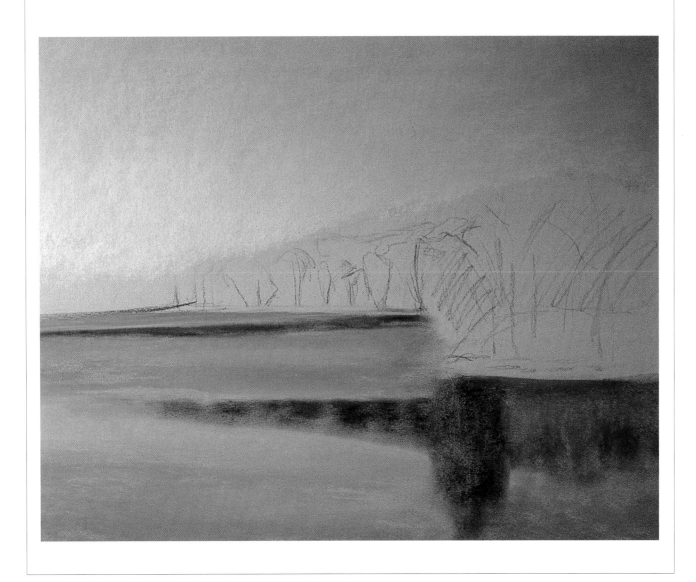

Step 5: Layering Your Way to Realism. Once the sky and water are established, begin blocking in the rest of your painting. Working first with darks, take a visual walk through the painting, visiting each color in turn. Block in the far tree line. Paint over that small piece of sky that was intentionally painted below the horizon, to create a seamless meeting point of sky and ground. Put down light layers—but you can get a good variety of darks by varying the pressure on each stick. Use the direction of your loose strokes to suggest the texture of what you are painting. For example, paint the grassy area with broad, vertical strokes to evoke the growth direction of grass. Paint the grass loosely, in bunches, still avoiding details such as individual blades of grass.

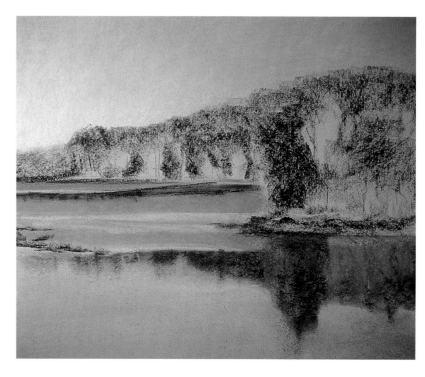

Step 6: Medium- and Light-Value Colors. After the darks are established, paint with medium-valued colors, applying them in layers, varying pressure on each stick. By blocking in colors next to and over each other in light layers, you'll obtain blended effects with interesting new color nuances. Now begin adding lighter colors—but not the very lightest yet. Use mostly the "big brush" block-in, but switch to "medium brush" when broader strokes just won't fit. Use mostly medium-soft pastels at this point, and continue to consult your photo reference and black-and-white sketch while painting.

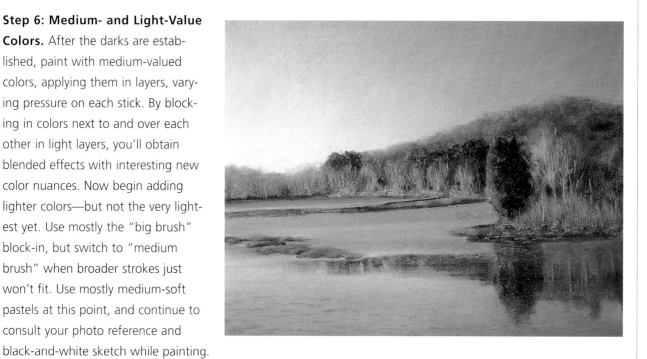

Step 7: Final Accents. Many layers later, it's time to re-evaluate. If you're having trouble with a painting, looking at it through a mirror often makes its weaknesses easier to see. Identify areas that need more touch-ups, color, or adjusting. Now comes the final fun part: adding highlights. Use your lightest colors to place final accents: the water ripples, made by dragging colors with a stomp; the tree trunks and grasses, made by lightly dragging the broad side of a soft-pastel stick on the paper in a vertical direction. When you think your painting is finished, leave it on your easel for a few days, catching quick glances or longer, thoughtful views of the piece. You may find a few more adjustments to make that you hadn't noticed earlier, before declaring—It's done!

Below: **Afternoon Reflections**
Pastel on pastel paper, 12 x 17½" (31 x 45 cm).
Collection of artist.

Returning to a Painting

As much as I try to arrange uninterrupted painting time, occasionally, something pulls my attention away temporarily. How do I find my place and focus when I eventually come back to a painting? I've devised a system, based on painting from dark to light, that helps me recuperate from untimely interruptions. I hope this strategy will be helpful to you.

When you return to a painting, the first thing to do is choose the darkest color in your working palette. Comparing your reference material and your painting-in-progress, ask yourself if the painting needs more of the color you have in your hand. If it does, use it; if it doesn't, put it down and pick up the next-darkest color in your working palette. Do this for each color you have used, and, before you know it, you will be back into the painting process as though you had never left your easel.

Below: **Tide**
Pastel on granular board, 28 x 37" (71 x 95 cm).
Collection of artist.
A landscape composition like this has a quiet power that comes from simplification, making it a good choice for the artist who is new to pastel painting.

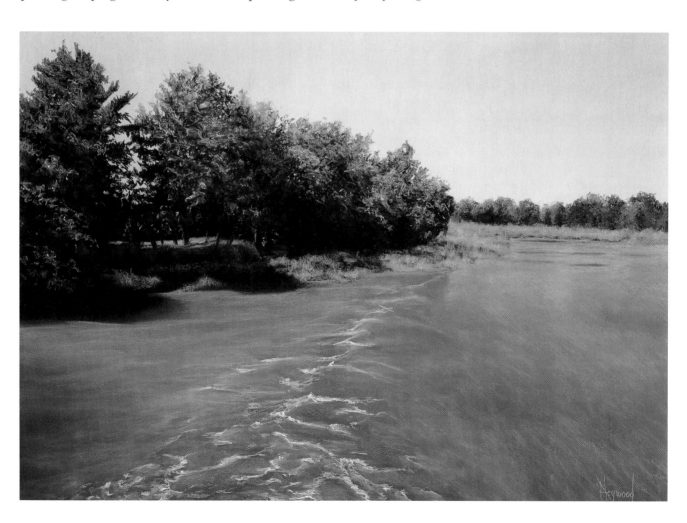

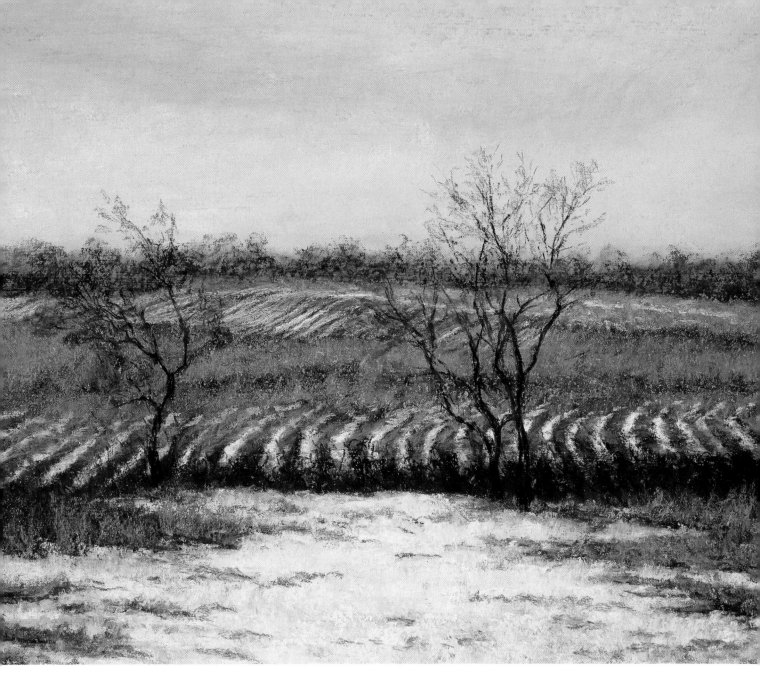

First Snow
Pastel on granular board, 15½ x 27" (40 x 69 cm).
Collection of artist.
*Muted colors dominate this piece, so the shape of the foreground
snow area, the placement of the two leafless trees, and the pattern
of the snow-filled rows became very important to its composition.*

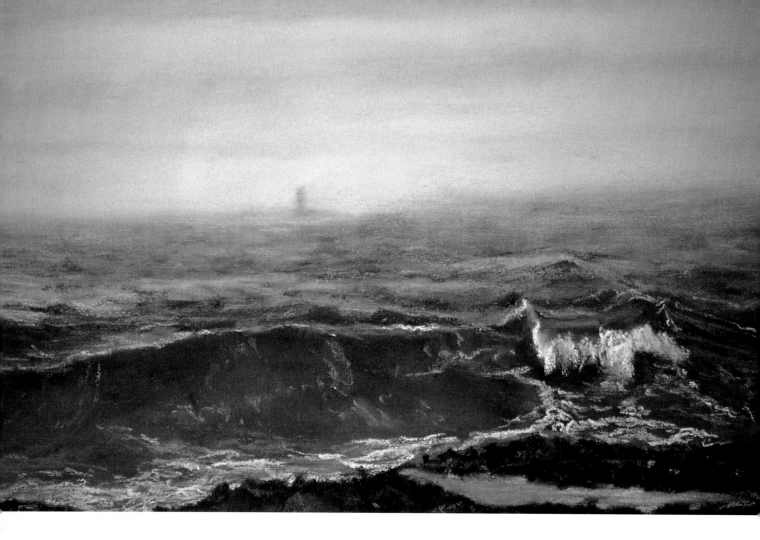

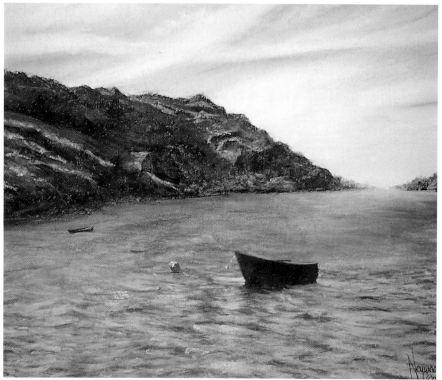

Above: **Inclemency**
Pastel on granular board,
11 x 20" (28 x 51 cm).
Collection of artist.
*For the most part painted in shades of
one color, this painting features soft and
hard edges and subtle value changes.*

Left: **Monhegan Series (Mananas Eve)**
Pastel on granular board,
16 x 20½" (41 x 52 cm).
Collection of artist.
*A few basic geometric shapes define the
large masses of this strong, but uncompli-
cated, scene—another example of a good
choice for the beginner pastelist.*

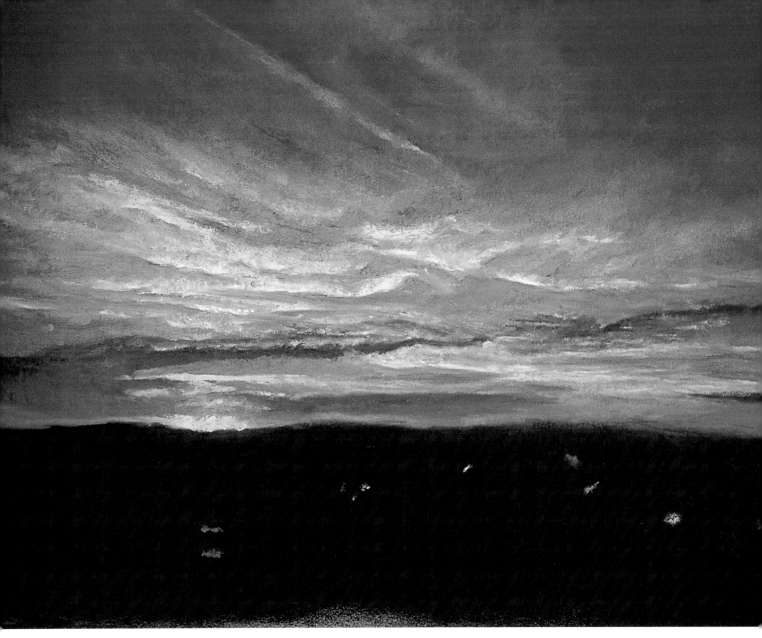

"S F" Sunset I
Pastel on granular board, 14 x 17" (36 x 44 cm).
Private collection.
*This striking sunset is made more compelling by the carefully
placed points of color in the dark foreground.*

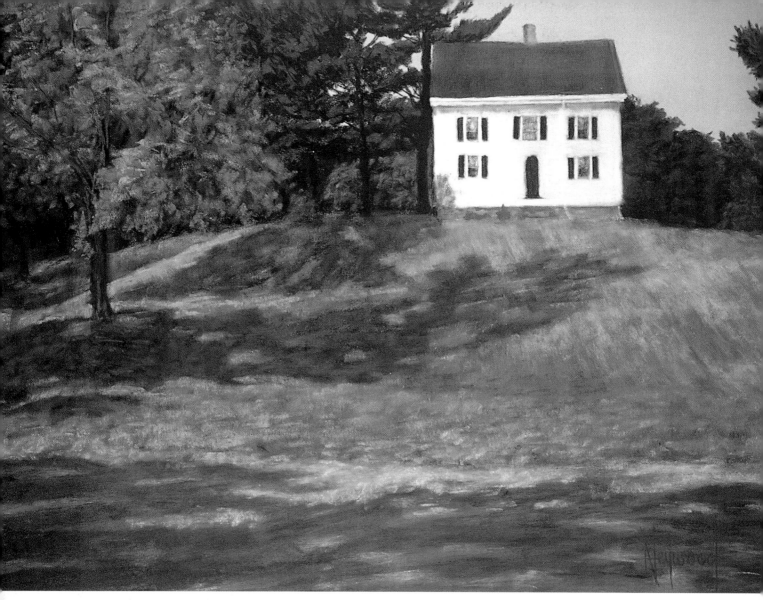

Above: **At the Crossroads**
Pastel on pastel paper, 16 x 23½" (41 x 60 cm).
Collection of artist.
*Shadows play a leading role in this landscape. Their shapes
and colors take the viewer's eye to the center of interest, the
house, which is also where the darkest and lightest colors meet.*

Opposite: **Slope**
Pastel on sanded paper, 19 x 16½" (49 x 42 cm).
Collection of artist.
*I deliberately exaggerated the tilt of this snow-covered
slope in order to create shadow diagonals, which contrast
with the dark upright tree trunks, bringing a sense of
dizziness to the scene.*

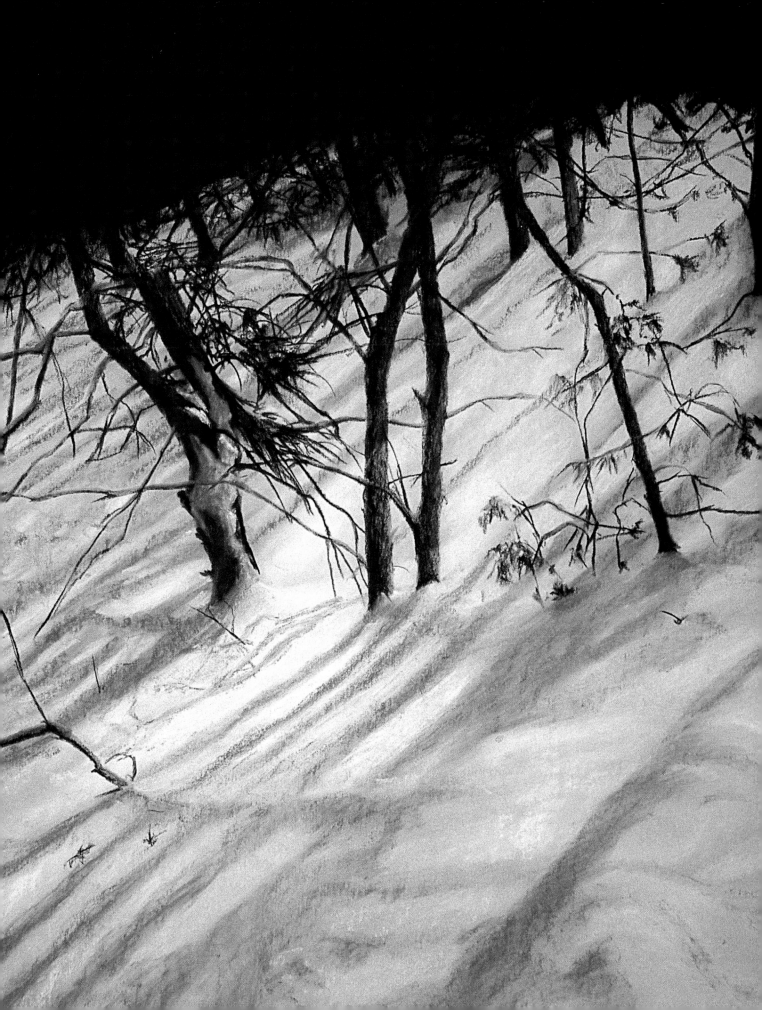

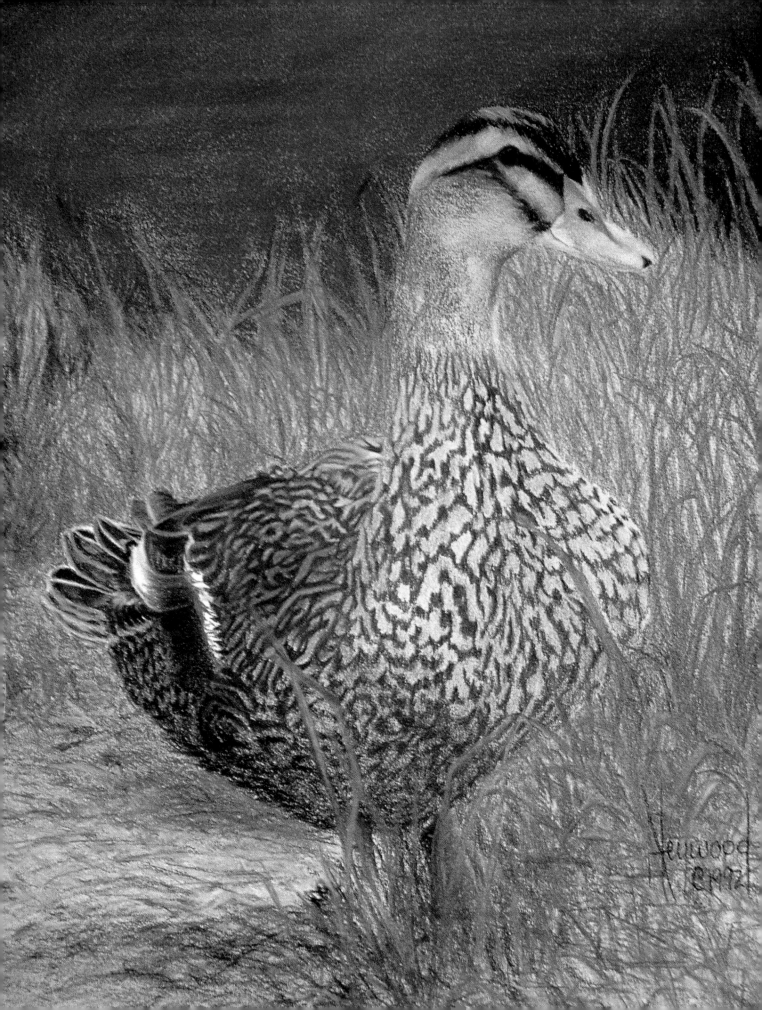

10

PAINTING AN ANIMAL PORTRAIT

Pet Portraiture Is Fun

Since I have a particular passion for animals, and painting their portraits is not often included in pastel instruction, I hope this chapter will fill that gap. Pets are enjoyable subjects to paint, particularly when they are "members" of your own family. But painting a pet portrait is not the same as creating a generic picture of a cat or dog breed, anymore than painting a person's portrait is the same as creating an idealized picture of a man or woman. Each pet has its unique physical characteristics that a realistic pet portrait should project.

The first step is getting reliable photographic references of your model; the more pictures the better, since you may have to piece together good parts of different shots—the tail from one photo, the face from another, and so on.

Opposite: **Mallard**
Pastel pencils on pastel paper, 22½ x 20" (57 x 51 cm).
Collection of artist.

Making Reference Photos

Here are my time-tested tips on how to photograph your pet. Plan to take your pictures outdoors on a sunny early morning or late afternoon, or indoors in a well-lit room—some with and some without a flash. Keep the background simple. Don't use instant-developing types of cameras.

Choose a spot where your pet is comfortable in a familiar setting. In addition to the person holding the camera—whether that's you or someone else—you'll also need another person to pose the pet. It's OK if that person gets in the photos, as long as the camera's view of the pet is not obstructed.

Get down or up to the pet's eye-level so you can look straight at the animal through your camera. Don't place yourself too near the animal; use a telephoto lens to get tight close-up photos. Take many photos, even several rolls, so you'll have a variety of poses—the pet looking left, looking right, head only, profile, complete body. A pet's particular pose is one of the elements that serves to project its unique personality.

DEMONSTRATION:
Pat's Cat

From your photographs, choose the shot you think will make the best reference for your painting; enlarge it to at least 4 x 6". Then transfer the image's "map" to your pastel paper. Using a grid to get that job done is one of the easiest ways to do that.

Materials
- *clear page protector*
- *ballpoint pen*
- *ruler*
- *2B graphite pencil*
- *sketchbook*
- *charcoal*
- *plastic gloves*
- *pastel assortment*
- *pastel paper*

Step 1: Grid Photo. Make a 1" grid on a clear page protector with a ballpoint pen and ruler—or, you can create a grid on computer and print it on a clear transparency. Tape the grid in place over your reference photo after you have completed your preliminary sketch.

Step 2: Preliminary Sketch. Using your reference photo, charcoal, and sketchbook, create your preliminary drawing, including values and background.

Step 3: Transferring Sketch. Choose a pastel paper that best reinforces the pet's color. With your ruler and 2B pencil, make a pale, 2" grid on the paper. Be careful not to push hard on your pencil; if you indent the paper, that area will never accept pastel—it will remain bare, no matter what you do.

Now refer to your photo reference under the clear grid. How many blocks wide does the image cover? How many blocks high? Count off the same number on your pastel paper. Allow for background, and using the grid lines on the page protector as your guide, work block by block, noting where certain lines of the image are located within the grid lines. For example, my cat's right ear starts about halfway up and slightly to the right of the left border of that grid's square, then angles down, slightly to the right. Find that same grid square on your pastel paper, and draw a similar line. In the same way, find other lines and shapes on your photo and transfer them to your paper, using the grid lines as reference points. Since I used a 1" grid for the photo reference and a 2" grid for the finished piece, the finished piece will be twice as large as the photo. You can use different size grids to make larger or smaller pieces.

If you've never tried a grid drawing before, the process may seem complicated at first—but soon you will begin thinking in terms of lines, shapes, and angles, instead of physical parts. Before you know it, properly proportioned and placed ears, noses, and tails will emerge. Take your time, and after the image is completely transferred, you may erase the grid on your paper or leave it. I left mine, since I knew I would be painting over all of it.

Step 4: Painting Darks First. This pet's coat has distinct markings, so begin by painting dark values with the "big brush" technique, switching to the "medium" or "small brush" to establish smaller areas of the dark markings. The colors used here are (hard) black and (medium-soft) dark blue, dark purple, and dark red-brown pastels.

Step 5: Mediums and Lights. Taking care not to completely lose the markings, paint medium values, such as terra cotta, green, orange, and dark yellow medium-soft pastels. Establish the eyes with the colors in your painting's palette, and then block in some light yellow and oranges, knowing that these colors will not be the lightest used. The cat begins to look like a rough version of the finished piece at this point.

Step 6: Background. Paint the background, choosing some of the colors used on the cat, and add other medium-soft pastels from your collection, such as dark terra cotta, medium green-blue, and yellow-green. Paint the background slightly into the cat's form. The fur will be adjusted there in a later step.

Step 7: Blend. After much paint is down on the background, blend it to create a textural difference between the cat and the background. Now, step back and evaluate your painting. Notice that up to now, you have used the block-in technique. Now, another technique will come into play in the finishing step.

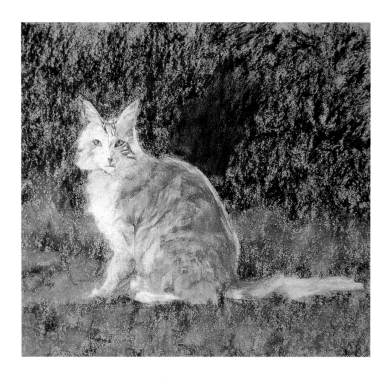

Step 8: Final Accents. Continue using your "big brush" for grass texture, but for final touches on the cat, use the "medium" and "small brushes" for the feathering technique—groups of thin, loose marks to simulate the cat's fur and markings. Create a textural difference where the cat's outline and background come together by fluffing the fur a bit. Study the cat's picture carefully for the direction of fur—an important identifier in describing an animal's physical structure.

Finally, reinforce darks as needed, then move up the color chain to medium values, then light. Once the lightest values are established, your painting should be finished.

Pat's Cat
Pastel on pastel paper, 13 x 17" (33 x 33 cm).
Collection of artist.

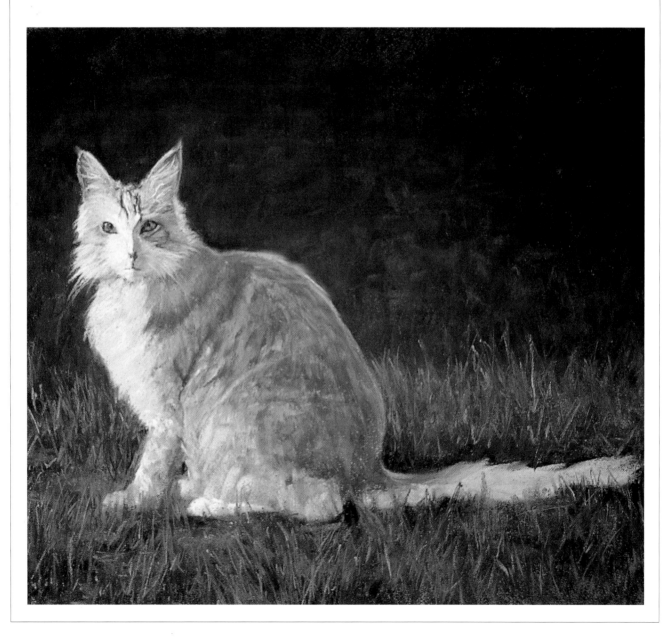

Above: **Hoover's Twilight**
Pastel on pastel paper, 11 x 15¼" (28 x 39 cm).
Collection of artist.
*This was my Hoover, my faithful painting companion
for sixteen years, in all of his old-age glory. I wanted
to depict his character and dignity, while including the
harshness of his arthritic limbs and cataract-covered
gaze. Placing him off-center in the composition
emphasizes his far-off gaze.*

Right: **Jamaica**
Pastel on pastel paper, 15 x 17" (38 x 44 cm).
Private collection.
*Jamaica's portrait was painted on the rough side of
Canson Mi-Teintes paper. Under this pet's delicate fea-
tures and somewhat hesitant pose lay an ever-faithful,
highly intelligent dog, which I hoped would come
through by having her face come forward, as the focal
point of my composition.*

Above: **Window Seat**
Pastel on granular board, 14 x 23"
(36 x 59 cm).
Collection of artist.

Sometimes inspiration is right there in front of you. This is my Georgie, who fell asleep watching me paint one day. He's a very calm fellow, which this pose projects. The white curtain heightens the light markings in his fur. For fine detail work as in the delicate lace of the curtain, I lightly scumbled a very soft white pastel stick along the edge of the curtain, varying pressure. Since I was working on a textured surface, its deep tooth also contributed to the lace effect.

Opposite: **Muffin**
Pastel on granular board, 20 x 16"
(51 x 41 cm).
Private collection.

Above: **Sabrina**
Pastel on pastel paper, 20 x 24" (51 x 61 cm).
Private collection.

Sabrina was a survivor, having been rescued from an abusive situation by her loving owner. This confident, watchful stance seemed the perfect pose to project her strength. As a final accent, her fluffy white tail stands out against the dark log.

11 | KEEPING YOUR PAINTINGS SAFE

Storage and Framing

Ensuring a long life for your pastel paintings starts from the very beginning, when choosing your working materials. But in addition to the suggestions in Chapter 1 about using quality materials, there are other factors that may influence the life of your paintings—namely, where they are stored and how they are framed. Those decisions should be based on your budget and the degree of your concern for the life-span of your paintings.

Store Unframed Work Carefully

Where original art is stored has an impact on its longevity. A place to store finished paintings is the bane of many an artist, but particularly pastelists, given the nature of the medium. Pastel paintings are always subject to smudging by touch, no matter how

Opposite: **Walk in the Woods IV**
Pastel and watercolor on granular board, 36 x 28" (92 x 72 cm). Collection of artist.

many layers of fixative may have been applied—so always handle your work with care. Store pastels in a clean, dry place, away from excessive humidity (not in a basement) or dryness (not in an attic). Do not store or hang pastel art on an "outside" wall of your house—and always keep your work out of direct sunlight.

Stacking

You may stack unframed pastel paintings safely as long as you place one carefully on top of the other, using no sideways movements, which would smudge their surfaces. First, tape a backing to the painting—lightweight foamboard works well—and place glassine (a non-abrasive paper sold in art-supply stores) over the pastel surface, taped at the edges. Caution: Waxed paper looks like glassine, but should not be substituted for it; the wax will melt onto your painting if it becomes too hot (left in a hot car, for example). Place the next painting faceup, over that, taping it down. Cover the top painting's surface with another piece of glassine and tape it down. Continue in that manner with as many paintings as your storage area will accommodate. Top off the stack with another

Above left: To store an unframed pastel painting, tape it to foamboard and cover with glassine. Other paintings may be stacked on it, each prepared in the same manner.

Above right: Another way to store unframed pastel paintings is to mat each, and then stack. Here, the matted pastel is placed between two pieces of foamboard, ready to be stacked.

Left: Creative alternatives to storage systems abound. Here is the "storage wall" that holds my color sketches and unfinished pieces. Some artists hang their finished paintings on a clothesline in their studio; others pin them to their studio walls with thumbtacks, or layer them between sheets in a large pad of paper. The best protection, however, is to frame them.

piece of foamboard, and secure the "sandwich" with large clips or tape on four sides.

Matting for Storage

An alternate method of stacking unframed pastel paintings is to mat each one. You will need a mat with a window cut to the size of your painting, or larger. Tape the painting at the top only to foamboard or other backing, cut to the overall size of the mat. Place the mat over your art, lining up the mat window with the painting's image. If the mat window is larger than the image, affix the painting to the backing with a tab of tape on all four sides so the art won't shift in the mat's window. Tape the mat to the backing by taping around the edges. Cover the entire face of the mat with foamboard, taping it to the "sandwich" on each side with a tab of tape. Many pastel paintings may be safely stacked and stored in this manner.

Identifying Stacked Paintings

Storing paintings in stacks prevents being able to identify them, unless you remove the top covering. One solution is to label each painting on the outside of the packaging. Another solution is to substitute glass or other transparent glazing for the top piece of foamboard, and secure it with sturdy wide tape, to both hold the package together and to pad the sharp edges of the glazing material for handling protection.

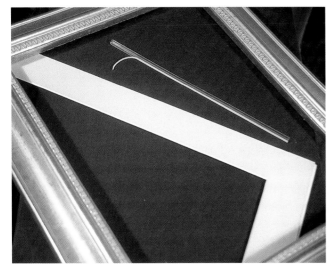

Unstacked Storage

Unframed pastel paintings can be stored without mats or backing by placing them in flat files or on shallow shelves, with only a sheet of protective glassine over each one—as long as they are not stacked. Secure glassine to the top surface of the painting for added protection, but by merely laying the paintings faceup, not stacked, in flat-file drawers or on shallow shelves, they will be safe.

Framing

There is nothing better than a tasteful frame to dress up a finished painting. My suggestion to beginner pastelists, however, is to create three or four paintings, then choose one to frame, rather than framing them all. Framing is very expensive, and you will find that your paintings will improve over time. Having one framed every so often will be a special treat, a nice way to keep track of your progress, and still stay within a reasonable budget.

Custom Framing

If you use a commercial framer, rather than doing your own framing, always go to a reputable shop. And *always* remind the framer, no matter how reputable, that your painting's surface will smudge if touched. I've heard many sad stories of pastels being smudged

Above left: Frame, mat, adhesive, and piece of plastic spacer are basic framing materials. Notice the partially peeled paper on the spacer's edge. After peeling off the paper, the adhesive edge adheres to the frame's glass.

Above right: Building up a mat with strips of acid-free foamboard or a mat of that material adhered to the back of a regular mat creates a gully where pastel particles may fall unseen.

inadvertently by professional framers. Also tell the framer not to spray fixative on your painting. If you choose to use fixative (which I do not recommend, as discussed in Chapter 6), it is much better to spray it on the art yourself, so you'll have more control over it, since fixative can change a painting's colors.

Also, I do not think it is necessary to dry mount a pastel painting, which adheres it to a stiff backing.

Do-It-Yourself Framing

If you want to frame your own work, the easiest and most economical way is to buy a frame that comes packaged with a mat and glass. Expect to replace the mat, since the ones included are usually paper thin; standard-sized precut mats are widely available. But even if you have a mat cut by a professional and do the rest of the job yourself, your cost will be considerably less than having a framer do it all.

Transporting Pastel Paintings

When traveling by car, as I do, here are some common-sense rules for taking your pastel paintings to and from class or other sessions away from your studio.

- **Unframed paintings** should be carried affixed to your drawing board, covered with glassine or foamboard, and placed on your car seat painting side up.
- Wipe the back and edges of your drawing board before placing it in your car. In wet weather, place the whole "sandwich" inside a large plastic bag. Stains left by raindrops will usually remain visible on a pastel painting.
- To prevent smudging, don't allow anything to touch the surface of your paintings. Protect each one as you would for storage, as described above.
- Pastels can stain fabric, so protect your car seat from pastel particles that might fall from an unframed painting.
- **Framed paintings** should be stacked faceup in your car.
- Pad the pressure points—where one painting leans on another—with pieces of bubble wrap, and cover with a clean blanket or sheet.
- Distribute the paintings' weight evenly: one faceup at right angles to the one below it, straddling the center of that framed painting. Never place one painting's weight directly on another painting's glass.

One final tip: When transporting framed pastel paintings, cover the face of each one with a blanket or folded sheet to protect against sun-induced condensation that can occur inside the glass. I once drove a very large, uncovered pastel to a show two hours away on a hot summer day. When I took the painting out of the car, the underside of the glass was completely covered with drops of water just waiting to rain on my painting. I was lucky: After standing the painting upright in an air-conditioned room for awhile, the water evaporated, without causing damage to my painting. The story ended well, but covering the painting en route with a blanket would have prevented the problem altogether.

Shipping Pastel Paintings

I have successfully shipped my pastel paintings to shows and clients all around the country for many years. However, for the beginner pastelist, shipping paintings is not likely to come up as often—but if you should want to share your work with out-of-town family or friends, here is some general guidance on shipping pastel paintings.

When I ship paintings, I beef up the spacers or strips of acid-free foamboard behind the mat to create a larger space between the glazing and the artwork. As for glazing: I use Plexiglas as glazing when shipping art—but since it's more expensive and requires special preparation, I don't encourage my students to use it.

What I do recommend is using special shipping cartons made specifically for paintings; the manufacturer is Airfloat System Strongboxes (1-800-445-2580). The boxes come equipped with all the necessary packing materials. You can use these shipping boxes more than once, and exhibition organizers in particular like the fact that they are easily reusable. Homemade wooden crates also work well but weigh considerably more, costing more to ship.

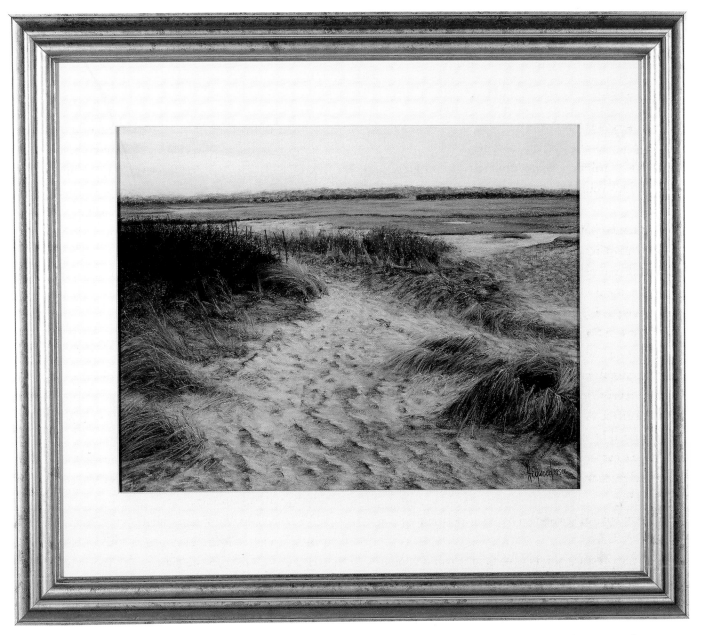

Morning Sands I
Pastel on granular board, 13 x 21" (33 x 54 cm).
Private collection.

This piece was framed with a mat that was built up in the back with strips of acid-free foamboard that are hidden from view, but which create a gully where falling particles of pastel dust can rest unseen. Always choose a frame that is deep enough to accommodate the thickness of a piece of glass, a deep mat, and/or spacer (separates art from glass), artwork, and backing (foamboard or other). I use frames with at least a ⅝" rabbet—the term for its depth. Careful measurement of all components is essential to make everything fit properly.

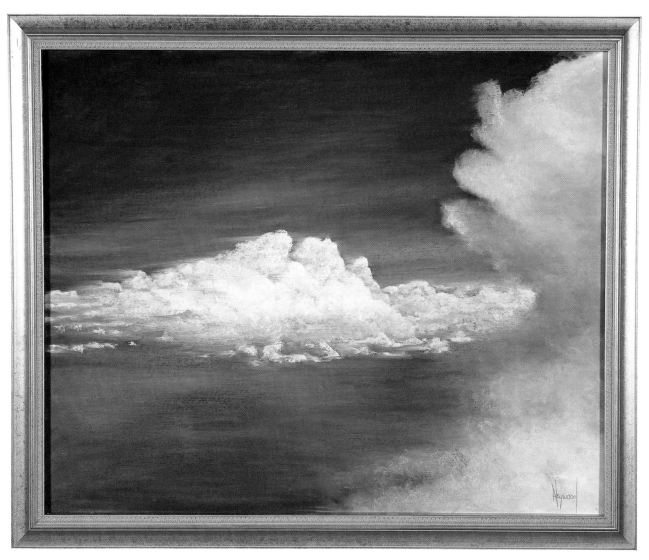

Above: **Cloudscape I**
Pastel on granular board, 32 x 40" (82 x 102 cm).
Collection of artist.
This large piece was framed using a plastic spacer to create extra breathing space between the glass and the painting.

Opposite, above: **Cloudscape II**
Pastel on granular board, 32 x 40" (82 x 102 cm).
Collection of artist.
As with its companion painting above, this frame has additional spacers to protect the glazing from touching the art.

Opposite, below: **Waves**
Pastel and watercolor on granular board,
9½ x 39½" (24 x 101 cm).
Collection of artist.
A painting with unusual dimensions such as this often requires custom framing. For shipping, sturdy boxes are available, made specifically for protecting framed pastel paintings.

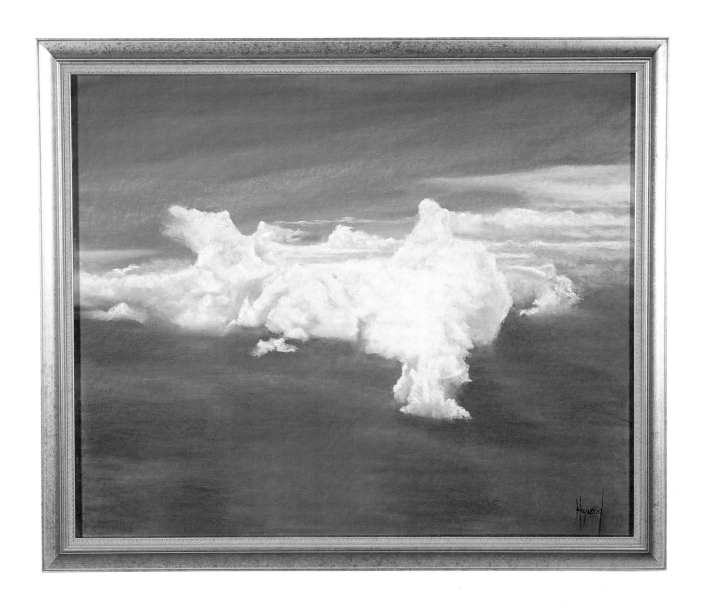

AFTERWORD

The Wide World of Pastel Painting

Be happy to know that you have just joined the growing ranks of people who love to paint with pastels. Whereas it used to be difficult even to find pastels in retail stores, now you have a vast selection of pastel products at your disposal through art-supply stores and catalogues. There are also magazines dedicated to pastel art; block-buster museum shows feature the medium; a separate pastel category exists in many juried shows; Web sites and professional organizations are devoted to pastel art and artists. So you have joined a large family. Congratulations are indeed in order!

Your Next Pastel Masterpiece

If you're wondering what more can be done with pastels, the choices are limitless. Experiment with different materials and techniques. Combine pastel with another medium, such as watercolor, which you can

Opposite: **Jamie's Venice**
Pastel and watercolor on watercolor paper, 30 x 24" (77 x 61 cm). Private collection.

use for underpainting. Paint in larger or smaller sizes than you usually choose. It's always fun to give yourself new and different painting challenges.

To reiterate some of the suggestions I made earlier—ones that I feel are especially important for the beginner pastelist—first, find yourself a place to paint where you can safely leave your art supplies. Set aside a regular two-hour block of time every day, every couple of days, or every week—whatever goal is most reasonable for you. Inform family and close friends that you will be busy on that certain day at that certain time. Take no phone calls. Keep this book by your side for reference. If you have trouble finding a time or place to paint, take a class or work-shop with a professional who paints in a style that you admire. It will ensure regularly scheduled time for your art, and added instruction about this exciting medium.

Finally, if there's any secret or magic pill to becoming a better pastel artist, it is quite simply: Paint! The more you paint, the more likely you are to improve.

Have fun!

La Strada
Pastel on granular board, 17 x 28" (45 x 71 cm).
Collection of artist.

Opposite above: **Tide**
Pastel on granular board, 28 x 37" (71 x 95 cm).
Collection of artist.

Opposite below: **Requium I**
Pastel and watercolor on watercolor paper,
18 x 28" (46 x 72 cm).
Collection of artist.

Index